WILDERNESS

WILDERNES

DEBRA BLOOMFIELD

essays by *Lauren E. Oakes, Rebecca A. Senf,* and *Terry Tempest Williams*

UNIVERSITY OF NEW MEXICO PRESS · ALBUQUERQUE

So, what have I said?

That we live in a precarious world;

that we are threatened by man's ingenuity;

that we need a less consumptive lifestyle in order to preserve the beauty and grace of our world;

and that our remaining wild places,

our wilderness,

have to be a most important element in all our thinking and all our doing.

—Margaret Murie, 1990

For ***Margaret Murie (Mardy)*** 1902–2003

adventurer, ecologist, mother of the conservation movement, activist, author, naturalist, wife to arctic biologist Olaus Murie,

instrumental in the passage of the Wilderness Act and in creating the Arctic National Wildlife Refuge, recipient of the John Muir Award

and the Presidential Medal of Freedom.

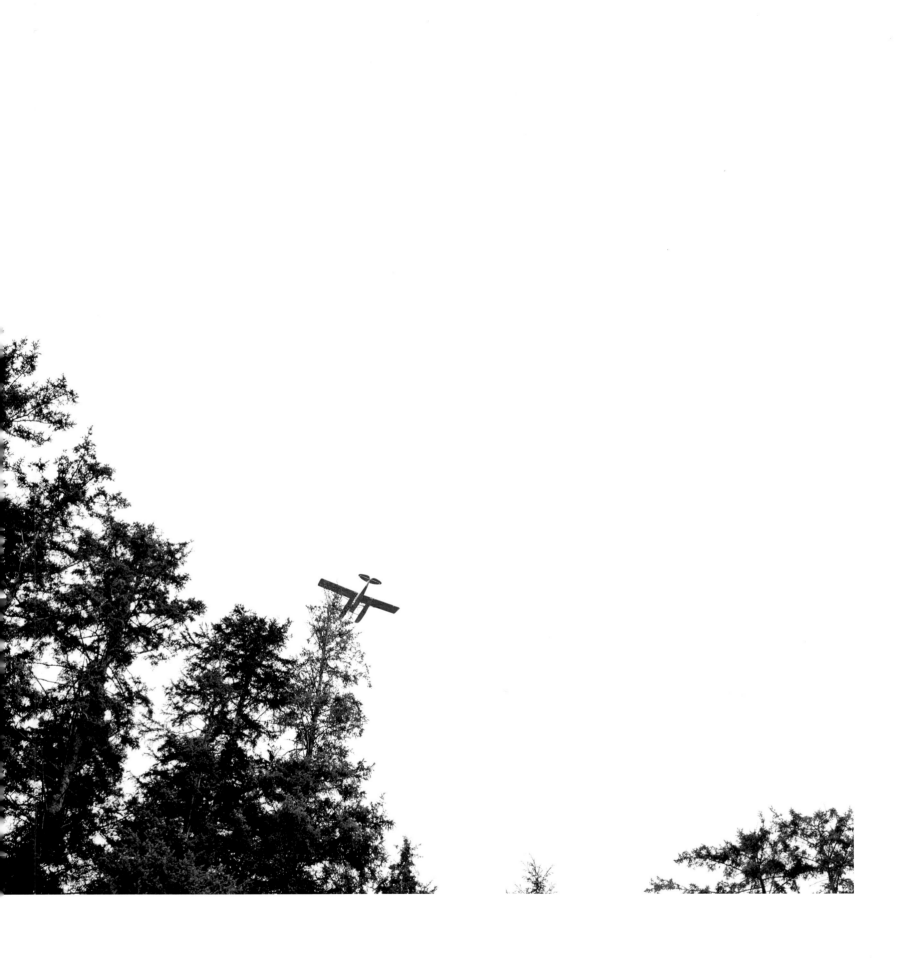

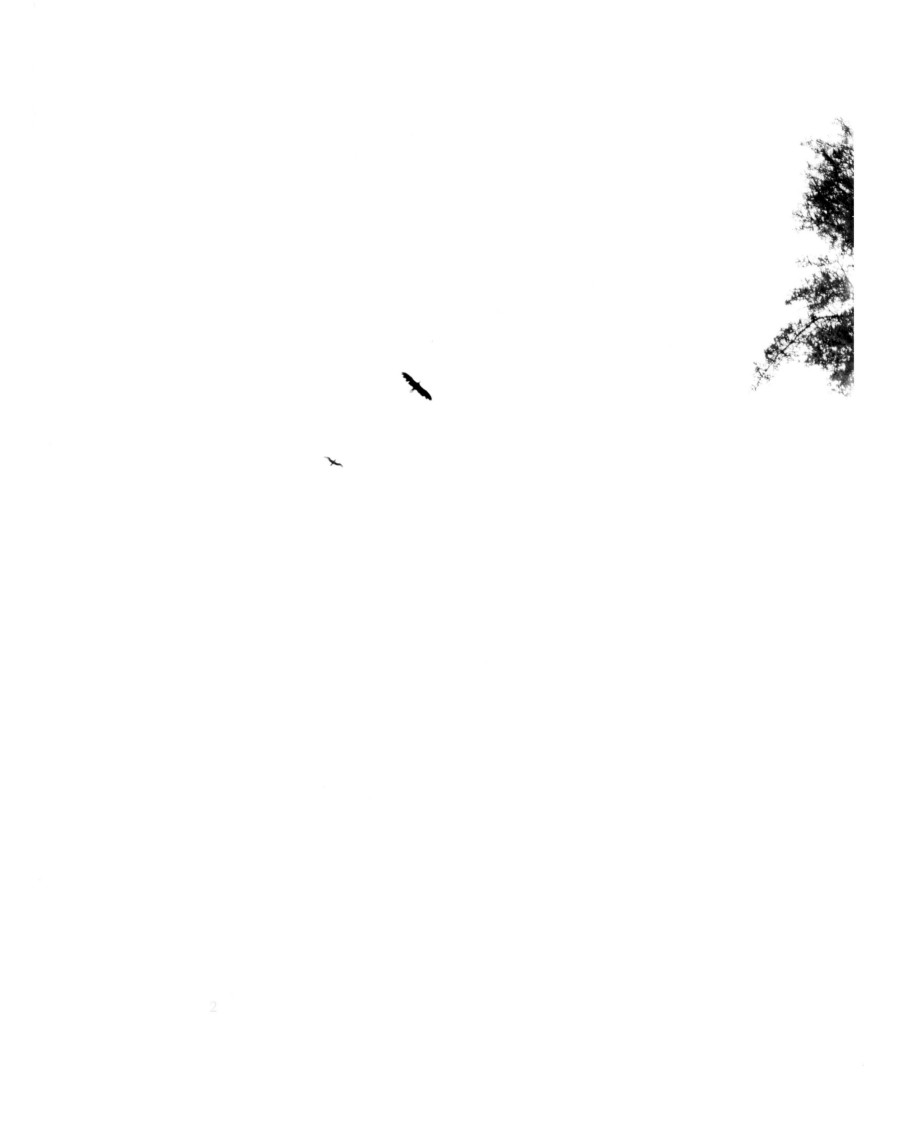

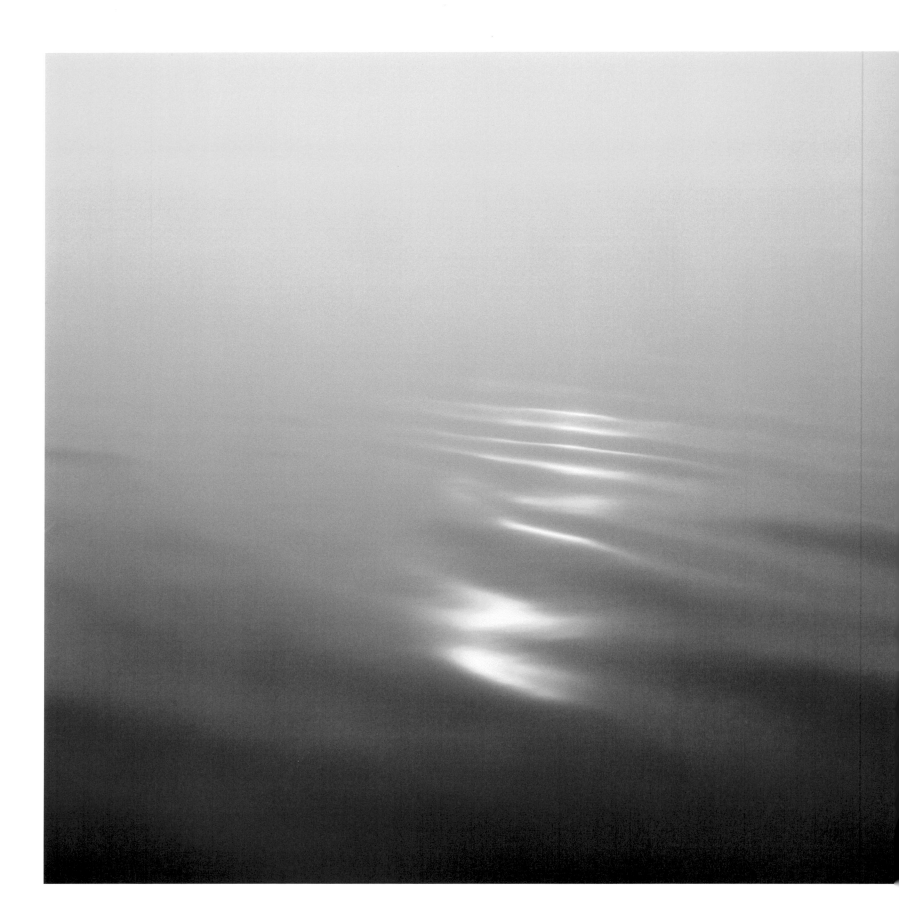

Rebecca A. Senf

HE PLACE IS WILDERNESS

In the five-year period beginning in 2007, Debra Bloomfield undertook her third photographic landscape project: *Wilderness*. The photographs she created do not physically describe what one particular wilderness place looks like—they are not intended to. She does not catalogue the elements that, when added together, make a wilderness. She does not worry about showing each detail she observed or conveying all the information she learned while she was there. Instead, she tells us what wilderness means. What it feels like to be there. What we need to understand about the place in order to care about it, appreciate it, value its existence, and be concerned about its future. Her photographs convey the experience of wilderness.

Bloomfield's artistic process involves focusing on one undertaking at a time, consuming her creative energies and including research on the historical, cultural, and sociological components of a place. Her first landscape project, published as *Four Corners* in 2004, began in 1989. For 12 years it took her down dirt roads, across the deserts, and under the big skies of the American West.

At the conclusion of that project, she began photographing the ocean. This series of eloquent and richly pigmented ocean-scapes, all made from a fixed vantage point, was published in 2008 as *Still*. As she photographed the ocean, Bloomfield thought about the ocean's water. Water flows and moves, it connects the planet's continents, and it is oblivious to political boundaries. Water is for everyone. These quiet pictures had more to do with contemplation and observation than exploration, and as she concluded creating her color-saturated water views, she began to yearn for a project that would put her back in the terrain, moving through the environment, immersed in the sights, sounds, and smells of a place. She wanted to be able to change the visual experience with her own movement.

Bloomfield was planning a trip to the northwestern United States and southeastern Alaska, and author Terry Tempest Williams, who wrote an essay for the publication of *Still*, recommended a forest that was not to be missed. Once she was there, Bloomfield became captivated by a raven's call. Initially, she could not identify the source of the noise she heard. Entranced and pulled in by the bird's throaty cry, she later described the sound as "primal," saying, "I had never heard anything like it." Bloomfield quickly decided that this forest would be the site of her next land-based project.

When exploring in the far north, one accesses the wilderness by air or water—these faraway places are not reachable by car. Yet, Bloomfield did not want to be confined to the aerial perspective, looking down from above. She wanted to be engulfed by the place. So rather than fly directly to the forests that would be her subject, she chose to make the last leg of the journey by water. Each visit to the wilderness was a process that unfolded in steps: first on an airplane, then a public ferry, then finally, on foot.

This shift from her regular life in the San Francisco Bay Area, to a place both wild and remote, was important. The soun
and images of this transition became part of the body of work, signifying the journey. It was a passage from the develop
populated and known, to the distant wilderness.

Bloomfield photographed *Wilderness* on a series of trips. Early trips were for learning, introductions, and getting to kn
the place. As Bloomfield settled in she realized that this place, announced by the raven, was important not only in itself, but
what it represented: wilderness. Bloomfield was becoming an emissary to the wilderness and her charge was to communica
what she found there.

Bloomfield did not begin this project with an environmentalist goal in mind, nor did she realize that the Wilderness A
passed in 1964, would be celebrating its half-century mark the year her photographs would be published. Her concern for t
value of a wilderness experience evolved organically, through exposure to the landscape, as well as its residents and wildl
Her concern for the place, and the idea it represented, grew as her relationship to it became more intimate and rich.

Bloomfield has walked through the crispy alder trees; she has observed a wounded raven, visited by its flock, let go of t
life and die; she has moved across a forested island in driving snow; and she has been viscerally, acutely aware that the pat
she walks belong primarily to the grizzly bears. Bloomfield, however, also knows that most of us will never do that. For m
of us, the populated and comfortably appointed lodges of the National Park Service may be the closest we come to the actu
wilderness. Others may never get that near. She also understands, though, that one does not have to hear the ravens in pers
or travel for days to stand in grizzly territory, to benefit from the existence of the wilderness. Wilderness is not only a pla
preserved by acts of government. Wilderness is an idea, fundamental to humanity.

. . .

The first time I saw prints from Debra Bloomfield's *Wilderness* project, I knew they were different. The images I saw, maybe h
a dozen, took up residence within me. I questioned myself later—how was it that such minimal images could convey so mu
could speak so loudly, and could captivate me so fully?

As Bloomfield built the body of *Wilderness*, she added pictures along loosely defined threads. One thread of photograp
contains views of open sky bordered by evergreen or deciduous trees. These patches of light sky overhead sometimes featu
birds, or a plane, or simply the bright atmosphere. Another thread contains pictures of the landscape, with a horizontal li
marking the distinction between water and trees, water and sky, water and mountain, or mountain and clouds. Sometimes the
landscape views are muted, abstracted, softened, or blurred by an intervening window, wet with precipitation, and thus faili
to provide a clear presentation of what is beyond. A slight variant on the landscape thread is the group of islands and wood
banks that join with glassy water and misty skies. Drifting in and out of fog, these waterscapes may be detailed and precise
elusive and dreamlike.

Pictures focused on the abundant waterways comprise another thread, and range from sharp-focus views of a vessel's fro
ing wake, to shimmering, ethereal abstractions of a smooth wave modulating the water's surface. And then there are the tre
tree branches laced with snow, trees dripping with water, and forests of trees. In Bloomfield's forest pictures, we simulta
ously see both the forest and the trees. From a distance these large-scale forest photographs read like color field paintings, w
alternating bands of white and gray or blue and brown. A horizontal strip of color divides distant background and foregrou

snow and on closer inspection is formed by the layers of receding trees coalescing into a dense overlapping band, where no space is visible between trunks.

Sometimes these threads converge, but each unique picture presents a facet of the wilderness and allows a contemplative experience of that particular view. Bloomfield's experience of wilderness places has inspired these photographs, and allows viewers to experience the elements she felt were most vital and sincere. These threads carry through the work like a musical leitmotiv, reassuring with a hint of the familiar and yet challenging with visual distinction. The prints also play a part in creating the fabric of the whole. Having been carefully spun, the individual threads are woven together into a tapestry, one that contains no narrative and leaves specific details to our imagination. However, the tapestry can still be read. It tells the story of our self-appointed emissary, her trip to the wilderness and what she found there. The tapestry helps us see, feel, smell, and hear the place she visited and leaves us with a powerful sense that we know this place. The pictures encourage us to ask, "How is a wilderness experience available to me?" and perhaps more importantly, "How do I make sure wilderness is protected and continues to exist?"

In my initial meeting with her, Bloomfield mentioned that she was making audio recordings as part of her project. At that time, I could conceive how these sounds might support the photographs, relate to the visual information, and yet parallel the minimalism of the images. The audio track, included here on a CD, is a first for Bloomfield and something she considers a collaboration between her and her son, musician Jake Bloomfield-Misrach. Together they took her five years' worth of digital recordings, which the artist had painstakingly captured, reviewed, identified, and edited, to create what Bloomfield refers to as a soundscape. Although this is her first photographic project to feature an audio component, her concern for sound has long been present. Bloomfield recounts: "As early as the *Four Corners* work I have been aware that I am influenced by the sounds I hear while photographing. With *Wilderness*, it seemed imperative to me that this work include sound."

The sounds I imagined when viewing these images—the hum of the ferry's engine, the birds calling overhead, the crunch of snow underfoot—are the sounds Bloomfield has included, although in the actual audio track they sound different than what my imagination supplied. Indeed, the various ambient sounds often require deciphering. Some of them are easily identified—a bird's cry or the announcer's voice as the ferry prepares to set out. Others begin as noises, percussive sounds, blips or beeps, and only through consideration can you attach them to an imagined source. Some of them, woven seamlessly into the soundscape, may never yield to identification.

With *Wilderness*, Bloomfield has created elegant and minimal photographs which, combined with an evocative soundscape, offer an intimate and powerful experience of wilderness. For many, it may be the closest we get to a personal experience of a real wilderness place. How lucky we are to have had such a sensitive, passionate, and capable emissary working on our behalf.

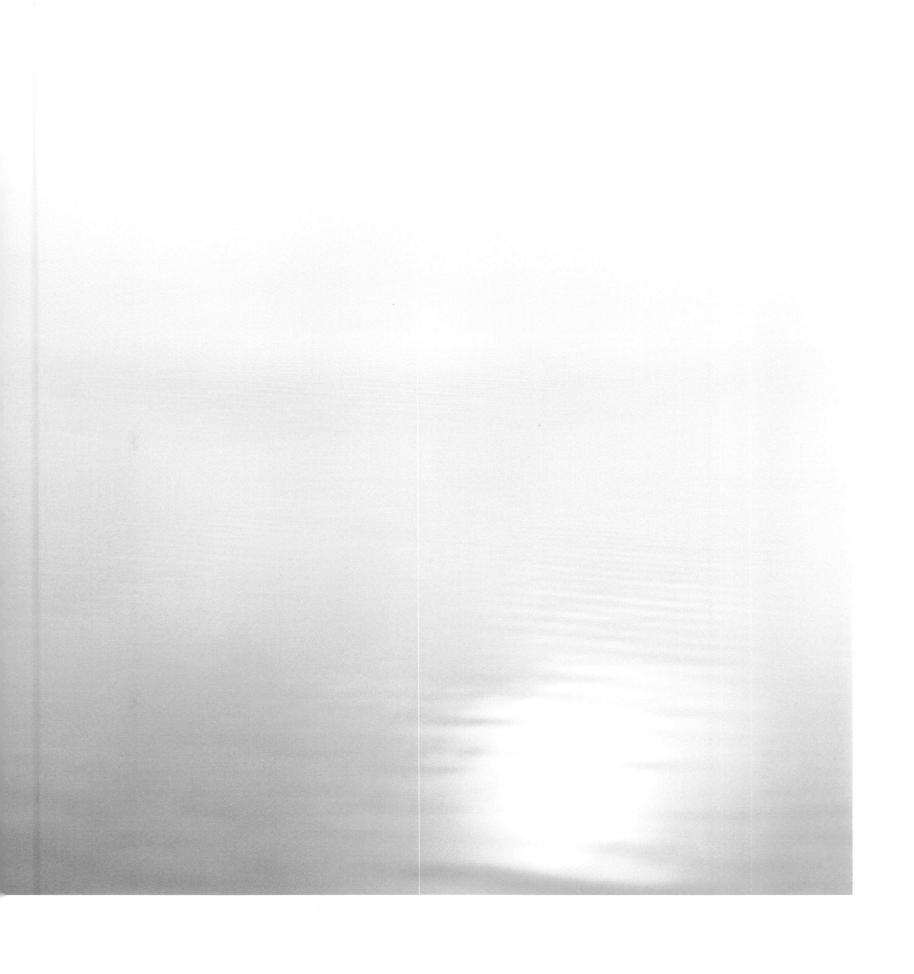

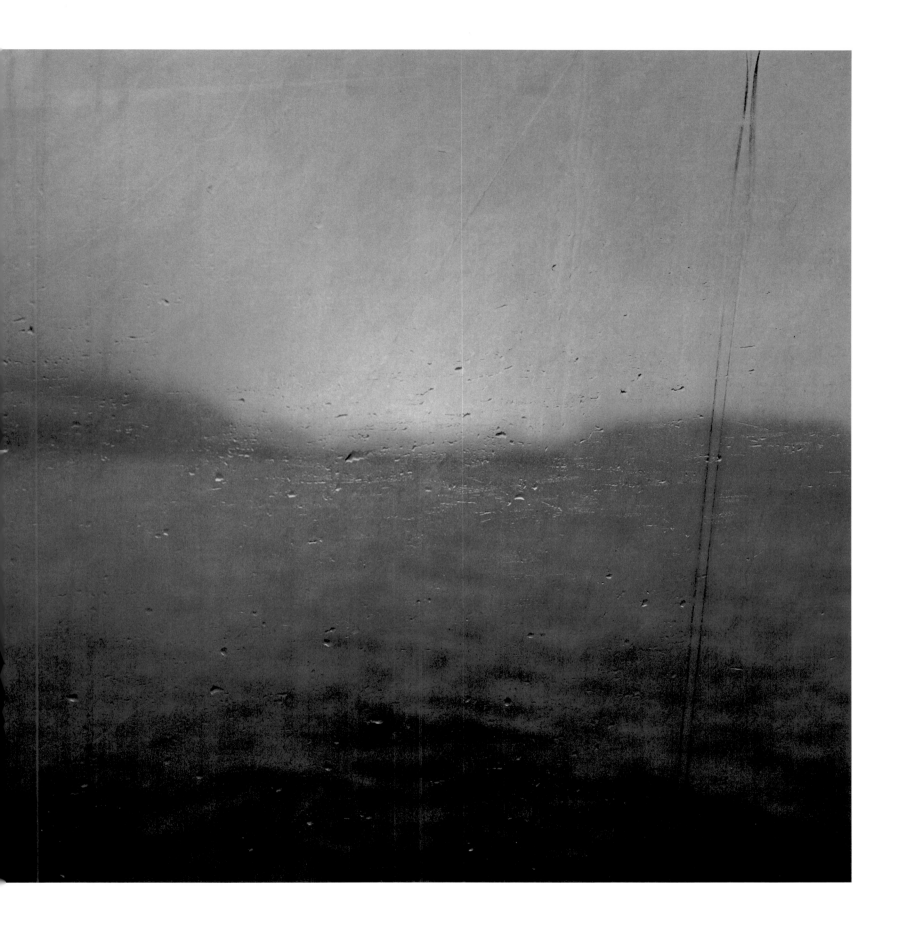

5

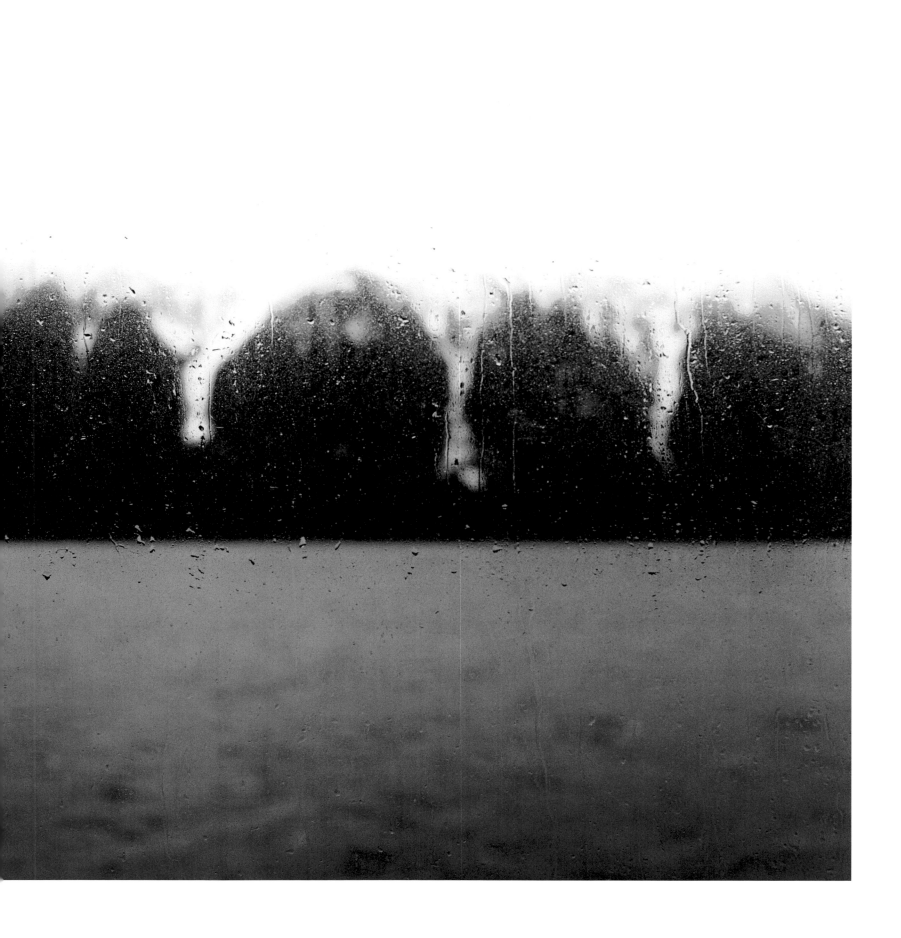

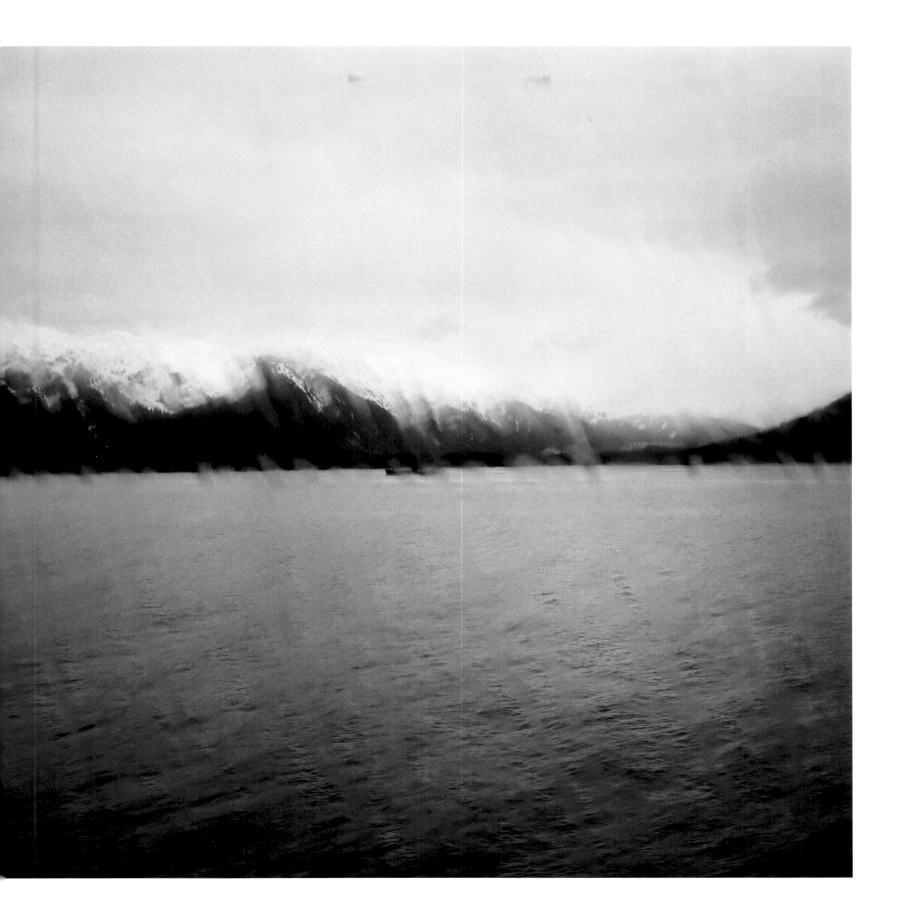

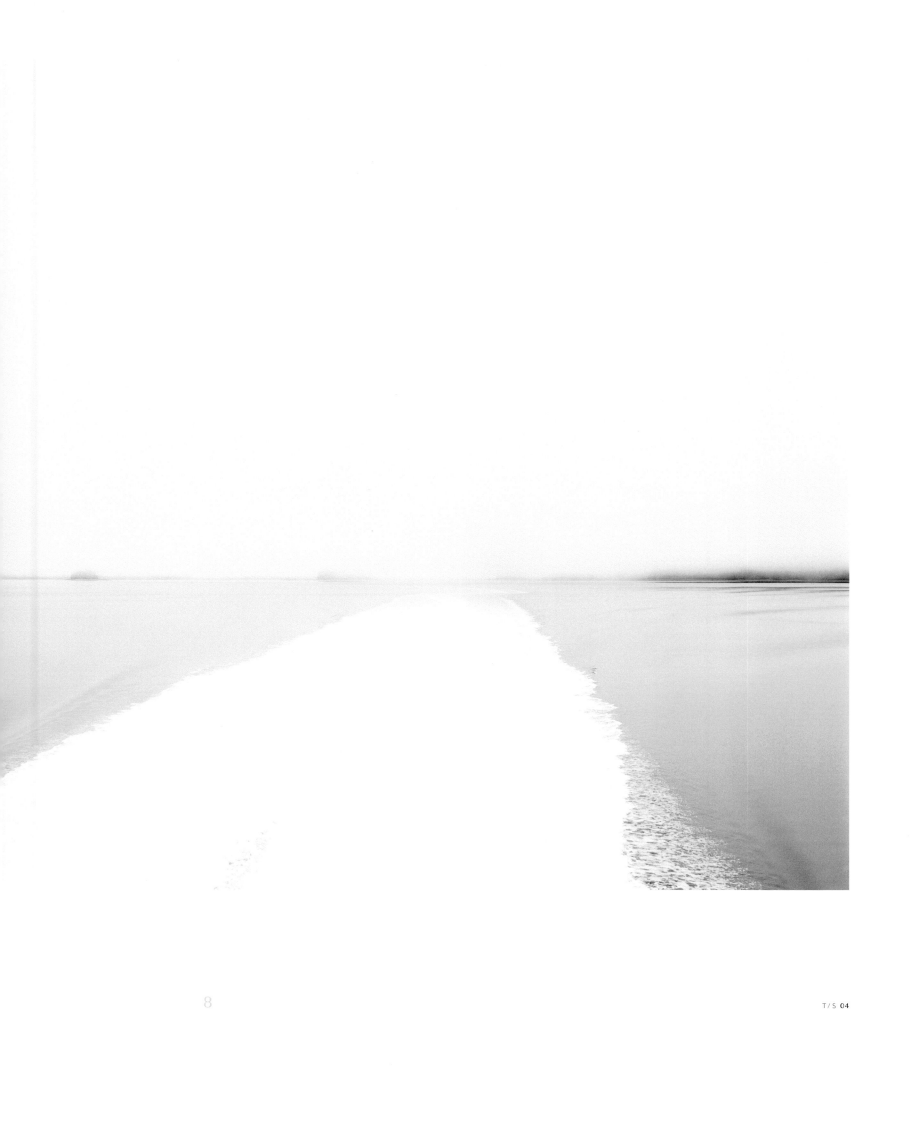

T H E W A K E O F B E A U T Y

It is raining. The sky is gray. A raven flies breaking monotony into motion.

It is raining. The sky is gray. Two ravens fly, their wing beats become a song.

It is raining. The sky is gray. A woman looks up in longing and listens.

To dare to stand in the melancholy of wilderness is to admit to the stillness of indifference. This is not the indifference of a lover's slight or the pain of being invisible to another person. It is the quiet wake of beauty. Wilderness holds us with a dispassionate gaze, an awareness that we are simply one among many, multitudes, in fact, of living, breathing, pulsating presences on the planet. We are a collective nervous system that responds. This knowledge is sobering and exhilarating, at once. We dissolve and dissipate into the cellular memory of our magnificent commonalities, destroying any sense of exceptionalism, be it a body or a nation.

To dare to stand in the melancholy of wilderness is to admit to our flesh and boneness of being. We are upright, mammals with hair, not fur or feathers, no scales or tails or claws or wings, only the skin of our humanity easily burned, bruised, or cut. We are a species among other species of plants and animals, peculiarly adapted for wonder within our shared complexity of form and function. It is a simple, brutal truth of the wild. We are special only to ourselves inside our rational and irrational minds.

To dare to stand in the melancholy of wilderness is to wonder if we do have something to offer, call it our niche or our species' contribution to the whole.

Could it be that our one overriding gift of evolutionary brilliance is our capacity to create art, our soul's response to beauty and pain that triggers empathy through an aesthetic ache that moves us toward expression? We pick up a pen and write words across paper. We hold a camera and frame a mountain in mist. We dip a brush in paint and splash color on canvas. We are not alone, even in the solitary act of creation, we are not alone in our desire to reply to the world that encircles us. It is this quality of sympathy, even pity in the purest sense, to feel with another that allows us not only to stand out but to stand apart on the edges of wildness to contemplate, consider, and celebrate both our separateness and wholeness, deeply.

Wilderness repeats itself. Wilderness is repetition. We, too, repeat ourselves.

It is raining. The sky is gray. A raven flies breaking monotony into motion.

It is raining. The sky is gray. Two ravens fly, their wing beats become a song.

It is raining. The sky is gray. A woman looks up in longing and listens.

It is raining. The sky is gray. The silence of melancholy returns.

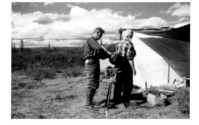

Olaus and Mardy Murie camping along the Sheenjek River in Alaska, circa 1961.

The weather system surrounding Debra Bloomfield's images are familiar to me, not because I have walked these same paths within the shrouded rainforests of the Tongass National Forest in southeast Alaska, not because I have felt that sa buoyancy underfoot, with the spectacle of green threatening to blind a desert dweller accustomed to red, but because this is internal landscape of the artist who waits and watches for the calm, wise heart of wilderness to reveal itself.

How can we be of use when the world is on fire even as it rains?

We rely on religion for its repetition of forms, which is comfort, and so it is with wild nature. Alaska becomes a kale scope of form turned color by the wrist of weather. The soft palette of seasons used to inform Bloomfield's vision creates atmospheric trance I do not wish to leave, only inhabit. It is the stark white of winter painted as the frozen lacework on tre It is the bold brushstrokes of branches silhouetted against twilight's blue. It is the dappled light of green shimmering in spri It is the eagle's stretch of wings across a canvas of yellow in the lingering loss of autumn.

I recall autumns in the Tetons when I sat on the porch with Mardy Murie at her home. She loved the fall, loved the gold cottonwoods that framed the face of the Grand, loved the bugling elk, loved the wedges of geese that flew often overhead. whatever our conversation might be over tea, it always circled back to Alaska. Always, her beloved wild Alaska was the to at hand.

"Wilderness itself is the basis of all our civilization," Mardy said. "I wonder if we have enough reverence for life to conce to wilderness the right to live on?"

Mardy Murie had this reverence for life and so did her husband, Olaus Murie, both of whom were iconic leaders wit the conservation movement, most well known for their passionate embrace of the Arctic where they spent their honeymo on a dog sled tracking caribou for the U.S. Bureau of Biological Survey in 1924. Thirty-five years later, they continued their l affair with Alaska doing survey work on flora and fauna in the Brooks Range, now known as the Arctic National Wildlife Ref for which they were champions.

I met Mardy at the Teton Science School in Kelly, Wyoming, when I was eighteen years old. Her passion for the wild ne left her and it entered me through her ongoing mentorship. I followed her to Denver, Colorado, to testify on behalf of the Ala Lands Act in 1977, and I followed her again to Washington, DC, in 1998 to witness President Bill Clinton place the Meda Freedom around her neck for her lifetime of work on behalf of wilderness protection. The tears in her eyes on that particu day were not for her and the recognition of being honored by the United States of America, but for her own recognition of love for the wild that she and Olaus shared together.

There is a photograph of Olaus loading up Mardy's shoulder bag in front of their tent where they were camping along Sheenjek River in Alaska. Mardy is wearing jeans and a red plaid shirt. Her white hair is pulled back in a braid as she looks o her shoulder at a horizon of clouds. Olaus has a tin cup hanging from his waist, a convenience for drinking water from the ri Both are wearing knee-high leather-topped boots with rubber soles perfect for walking on tundra. There is also a motion-pict camera on a tripod in front of the couple, evidence of their desire to film what they see and share it with others in the name protecting Alaska's wildlands.

Conservation is a generational stance and it is often rendered through art.

It is raining. The sky is gray. A raven with folded wings disappears into the forest.

There is no place to hide, not even in wilderness, especially in wilderness. This is not the time to stand on its edges looking in. We must act. We must create. We must participate in the art of the wild. The Muries helped create the Wilderness Act of 1964 on the front porch of their homestead with a community of friends. Debra Bloomfield is creating a body of work for our eyes and ears that beckons us to experience our own wild hearts beating in harmony with the heart of the Tongass National Forest, now threatened. We, too, are threatened by our own insulated nature. What are we creating through the wealth of our own disengagement with all things wild?

It is raining. The sky is gray. We have gone inside and are now looking outside.

Behind glass t h e w o r l d i s n o t i n f o c u s b u t a b l u r Raindrops become teardrops become the interiority of self. We can no longer see beauty.

Melancholia is a condition characterized by depression, guilt, hopelessness, and withdrawal. It is also associated with a sense of gloomy forebodings. We wonder where we belong. The wilderness of melancholy has us standing in the center of our own isolation, where the world becomes smaller, darker, and more desperate. The melancholy of wilderness is something quite different, an antidote to despair, inviting us to stand inside the community of nature where we can embrace our humility and allow ourselves to fully feel the terror, the fragility and power of our relations within the spiraling velocity of life. Before us and behind us, we engage in this quivering web of the wild.

There is silence in the beginning.
The life within us grows quiet.
There is little fear. No matter
how all this comes out, from now on
it cannot not exist ever again.
We liked talking our nights away
in words close to the natural language,
which most other animals can still speak. . . .

Before us, our first task is to astonish,
And then, harder by far, to be astonished.

— Galway Kinnell

Debra Bloomfield's astonishing palette of blue and black and white and gray-green is not somber as much as sobering in its beauty and clarity of forms. Wilderness is a form, a form worth repeating as the natural language of creation. It is a portrait of our own survival, poignant and pressing.

I feel both the joy of wildness and the absolute pain in terms of what we are losing. And I think we're afraid of inhabiting, of staying in this landscape of grief, yet if we don't acknowledge the grief, if we don't acknowledge the losses, then I feel we won't be able to step forward with compassionate intelligence to make the changes necessary to maintain wildness on the planet.
—Terry Tempest Williams, 1994

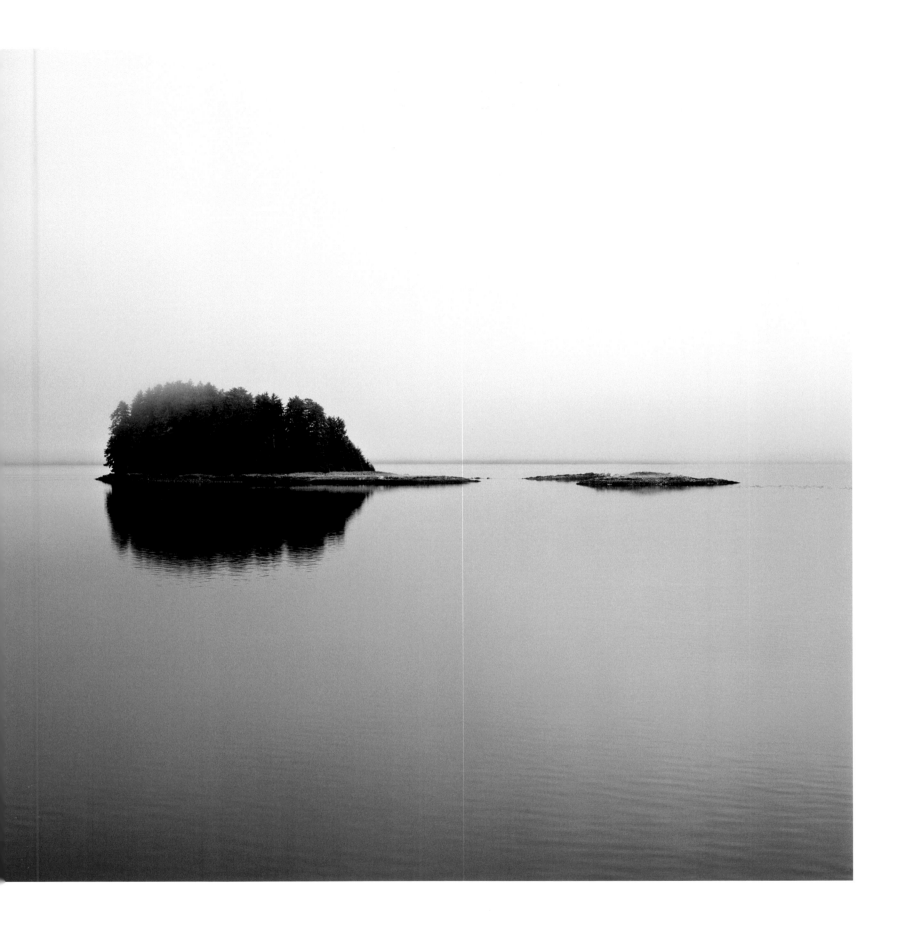

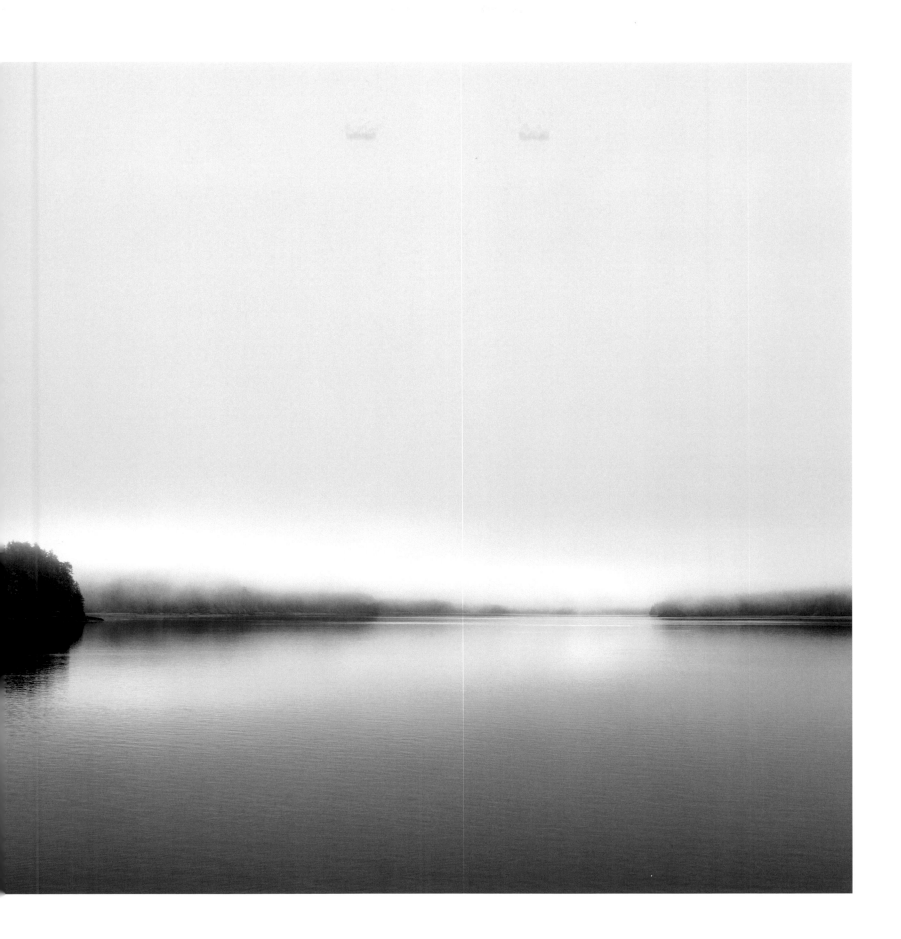

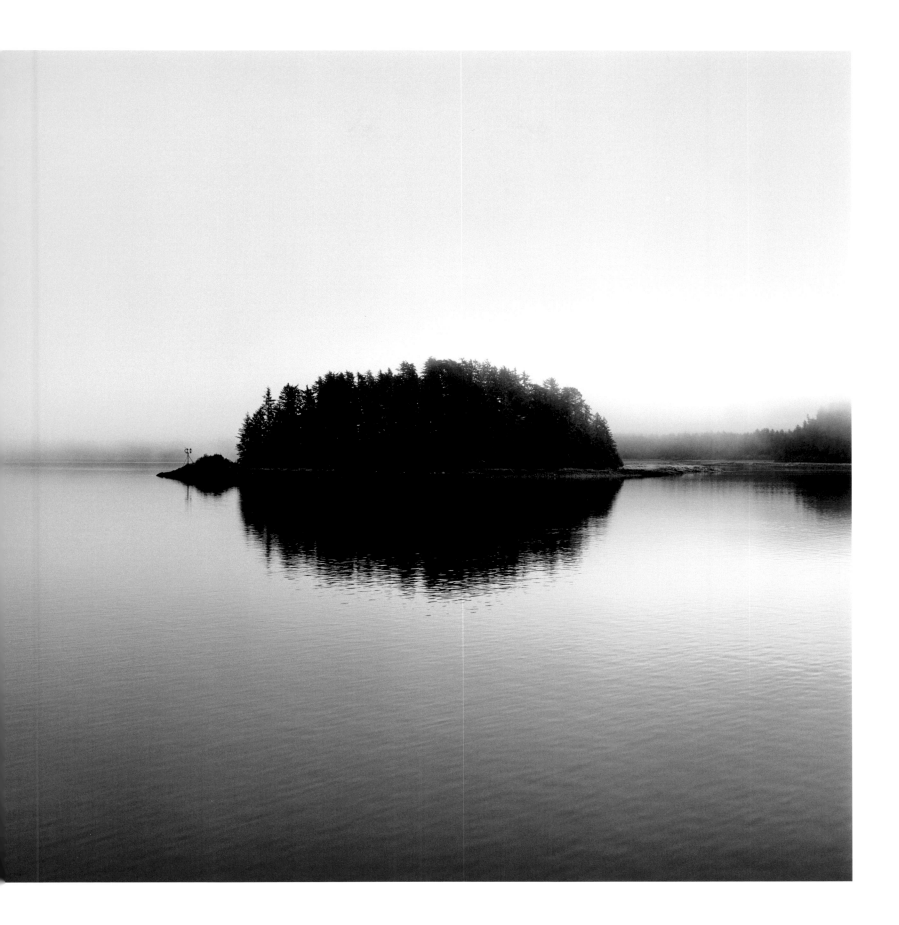

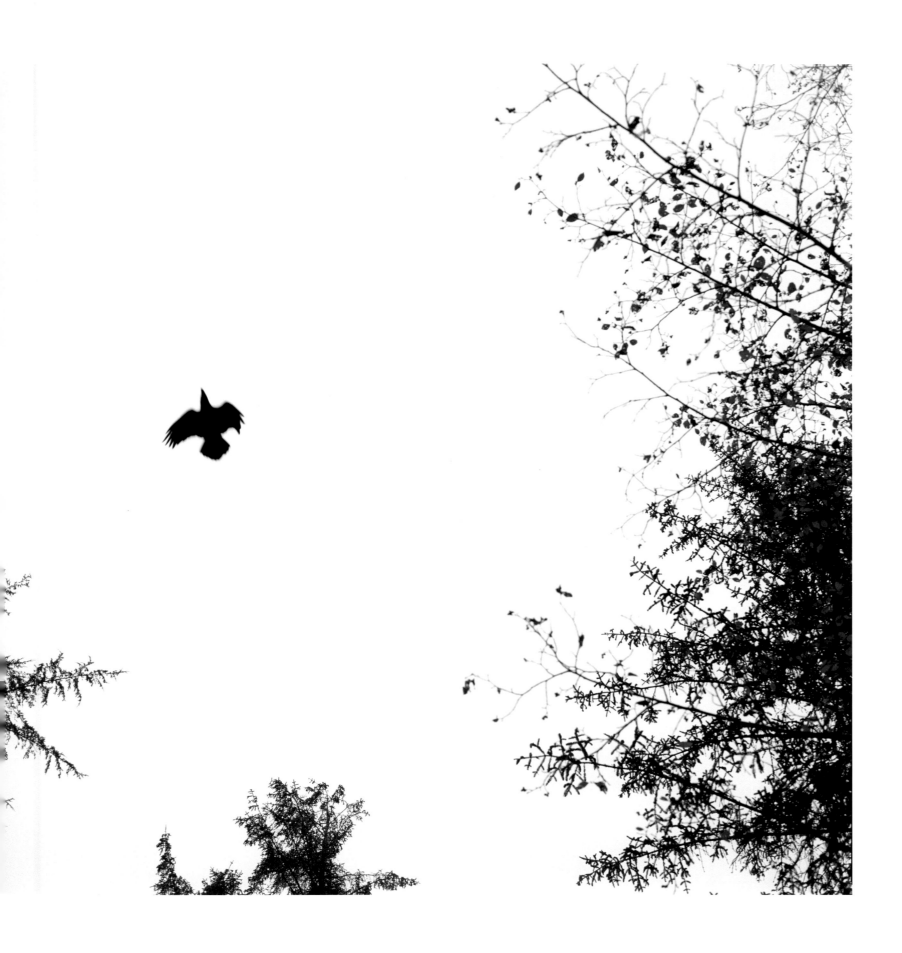

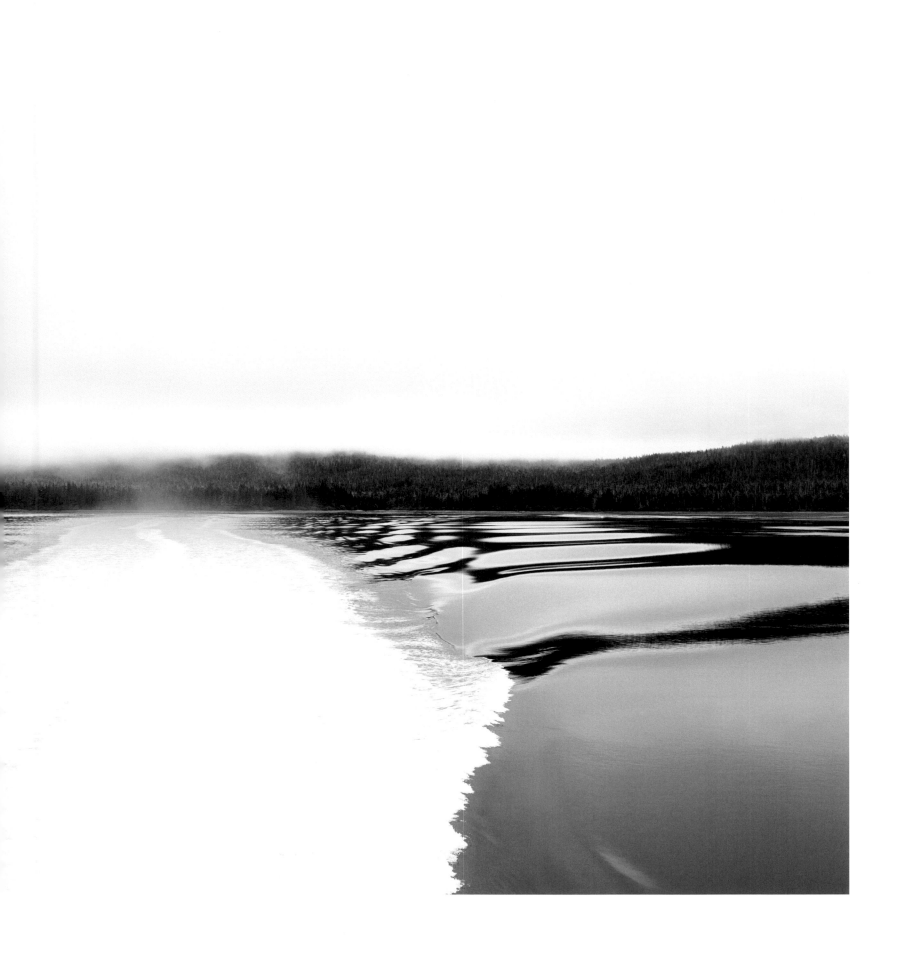

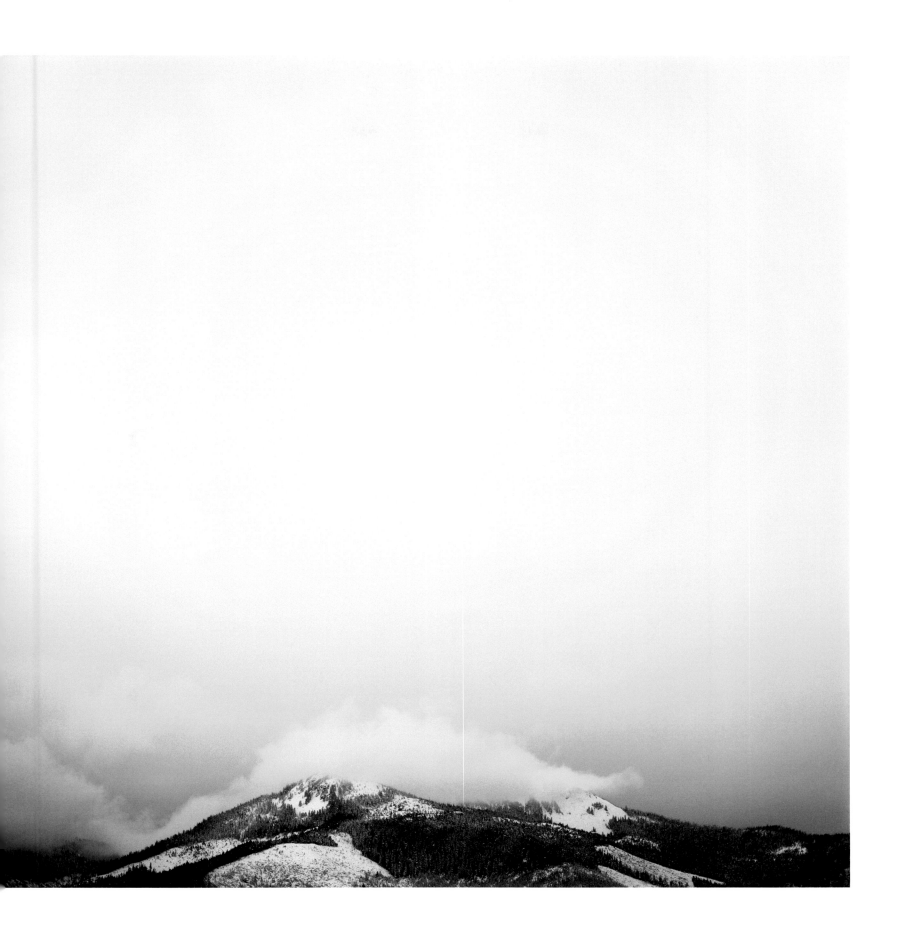

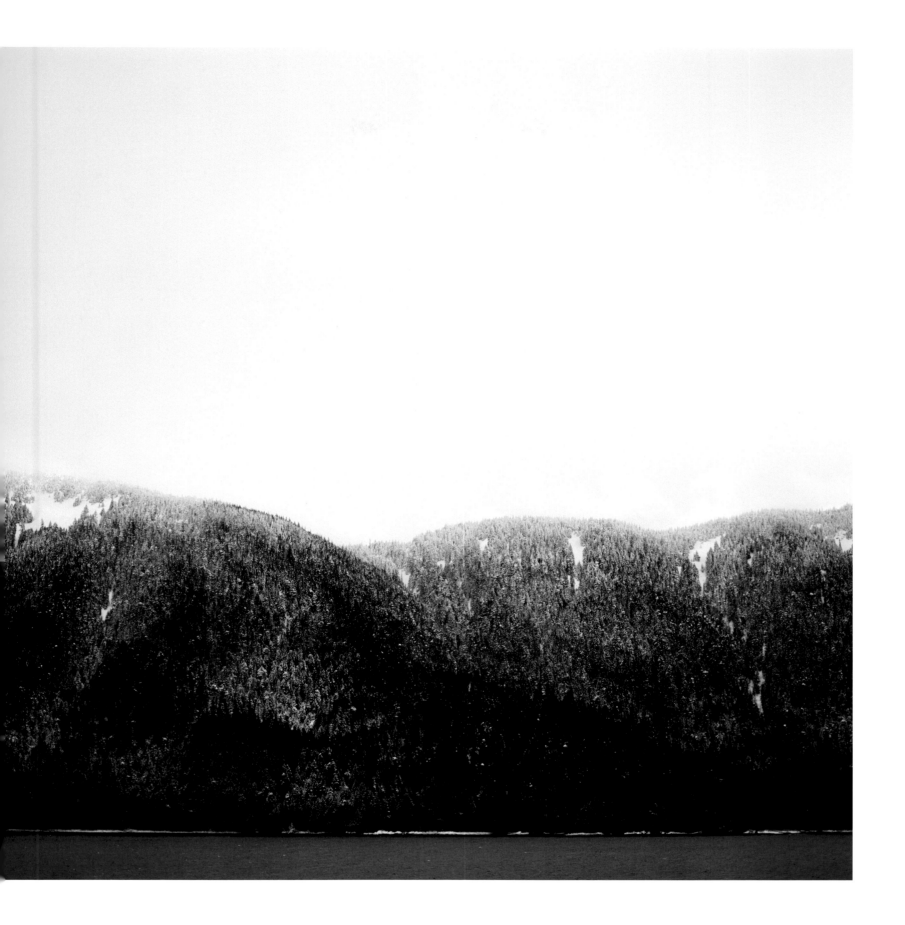

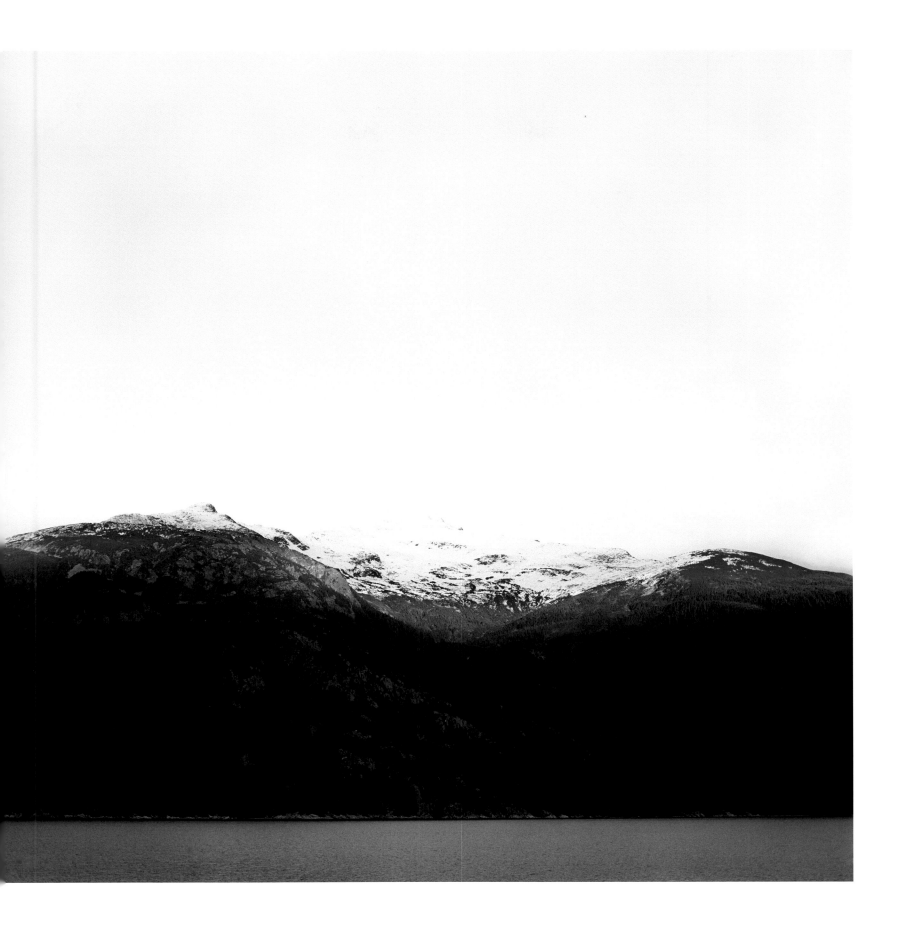

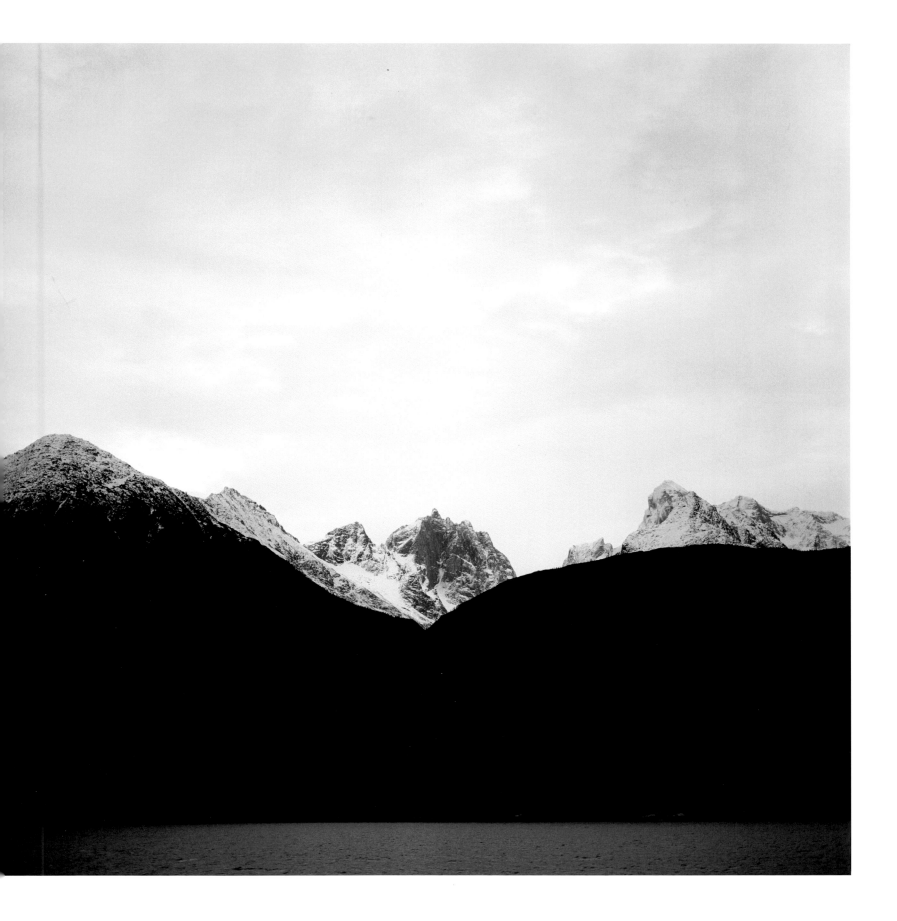

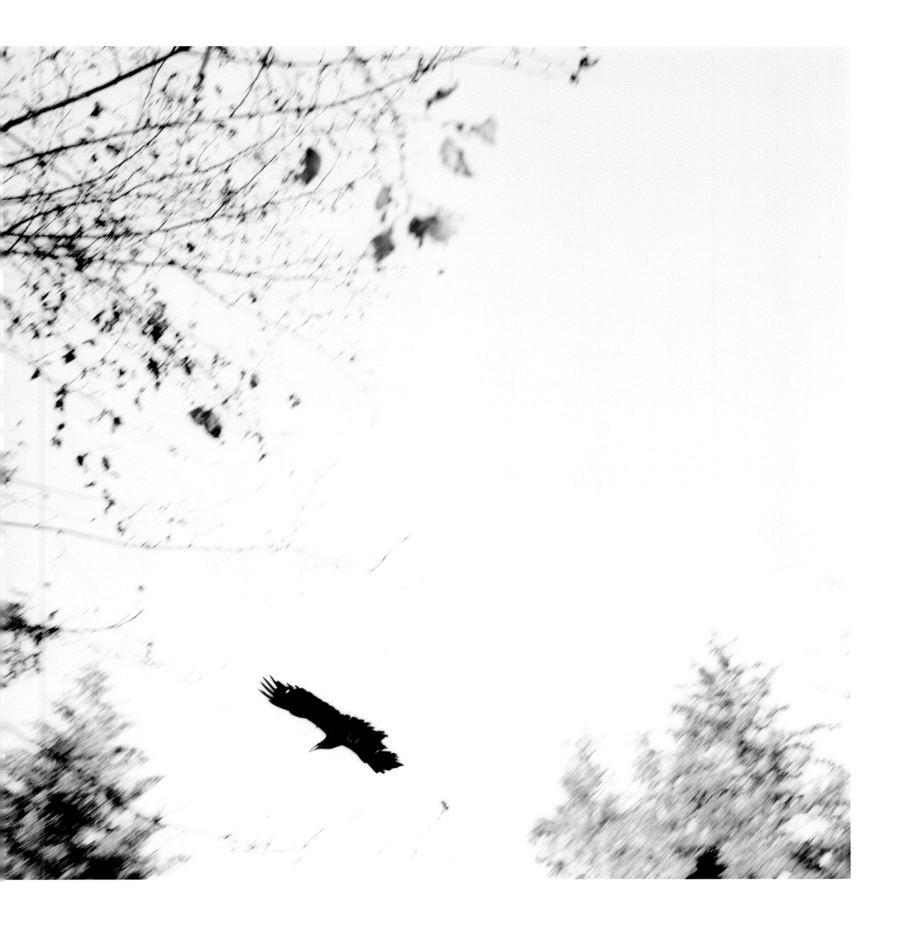

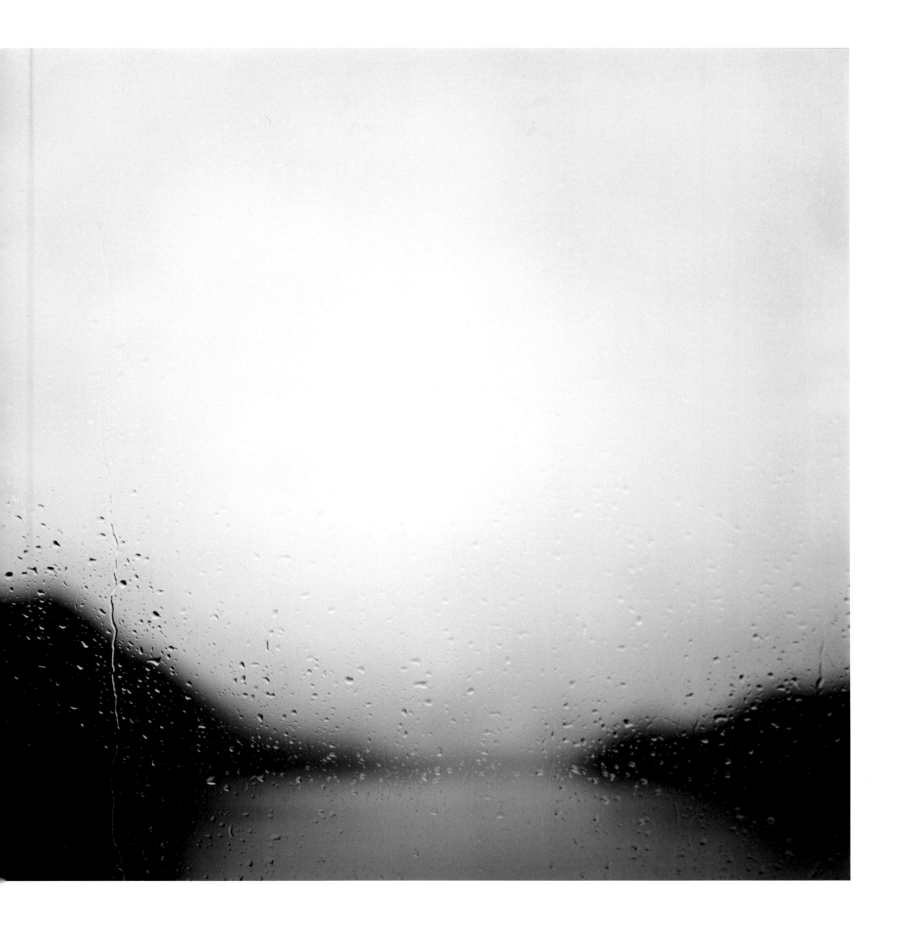

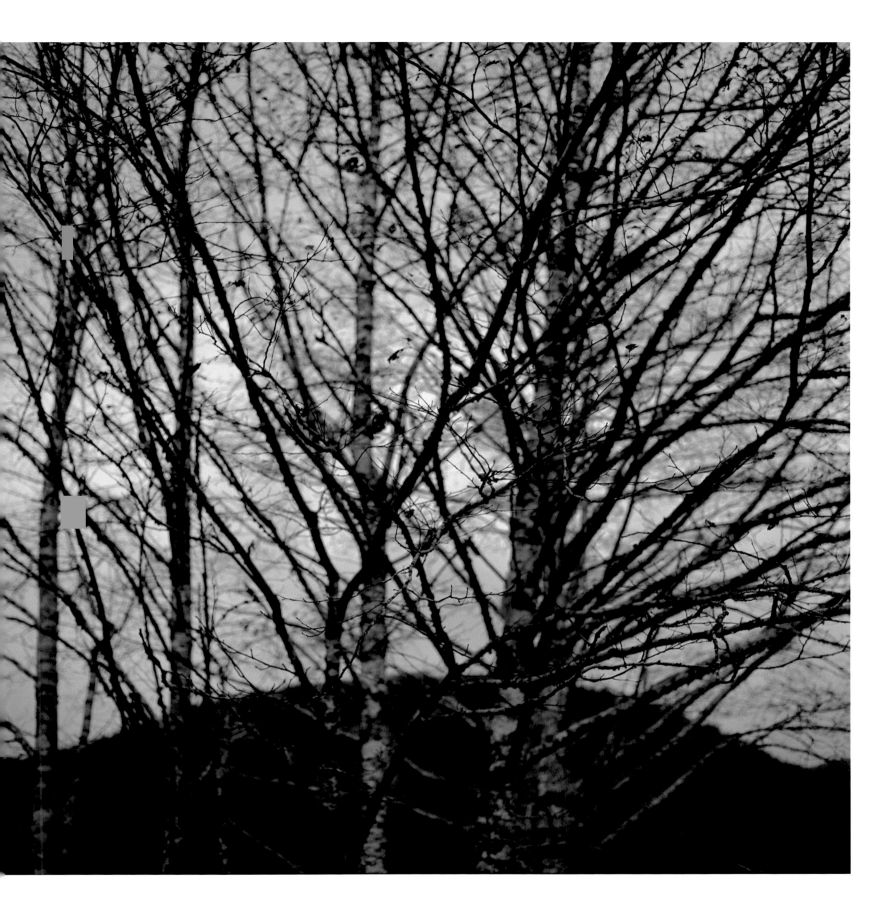

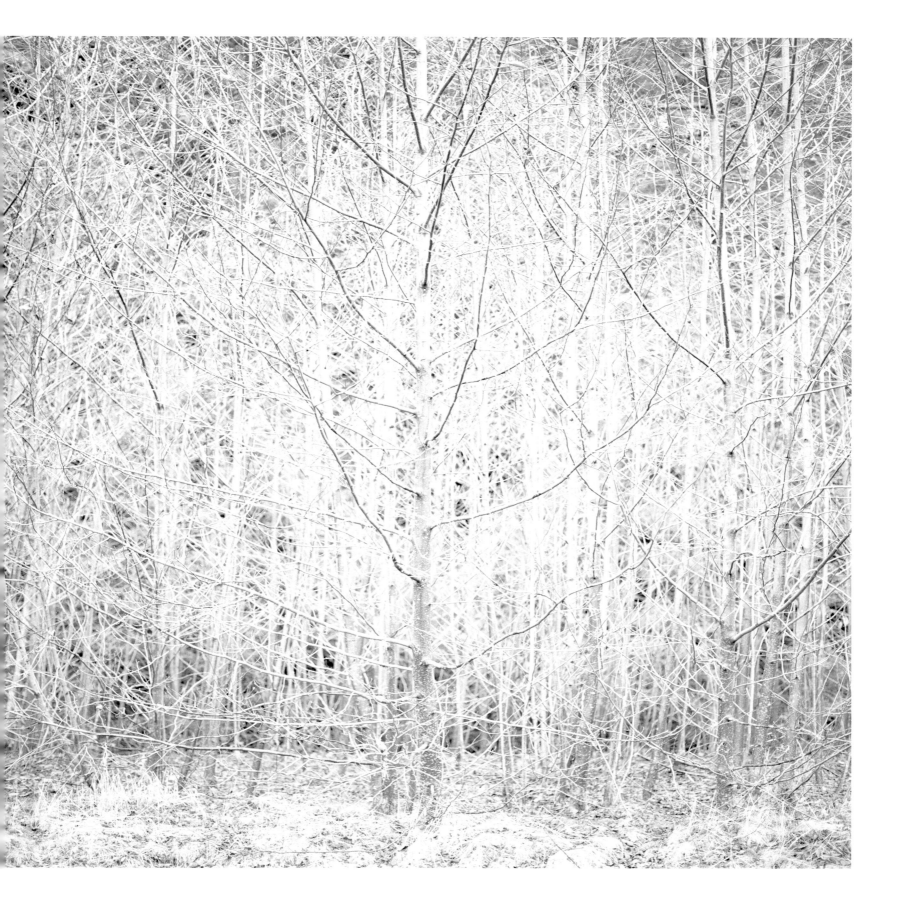

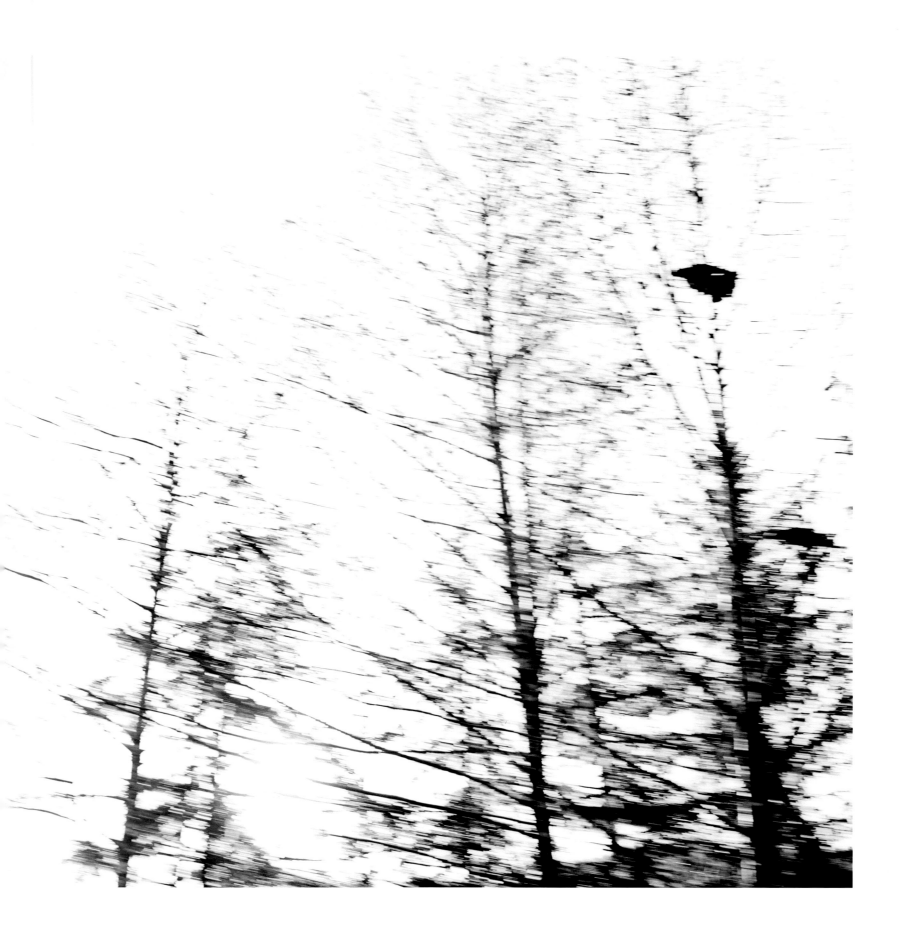

23

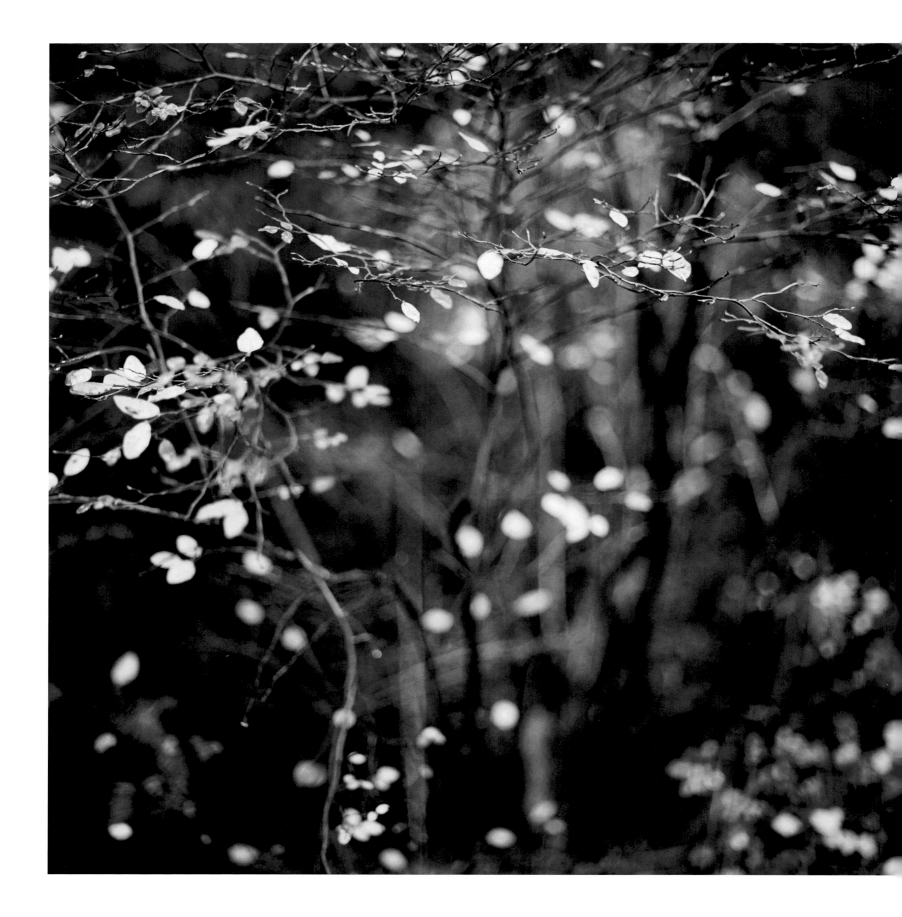

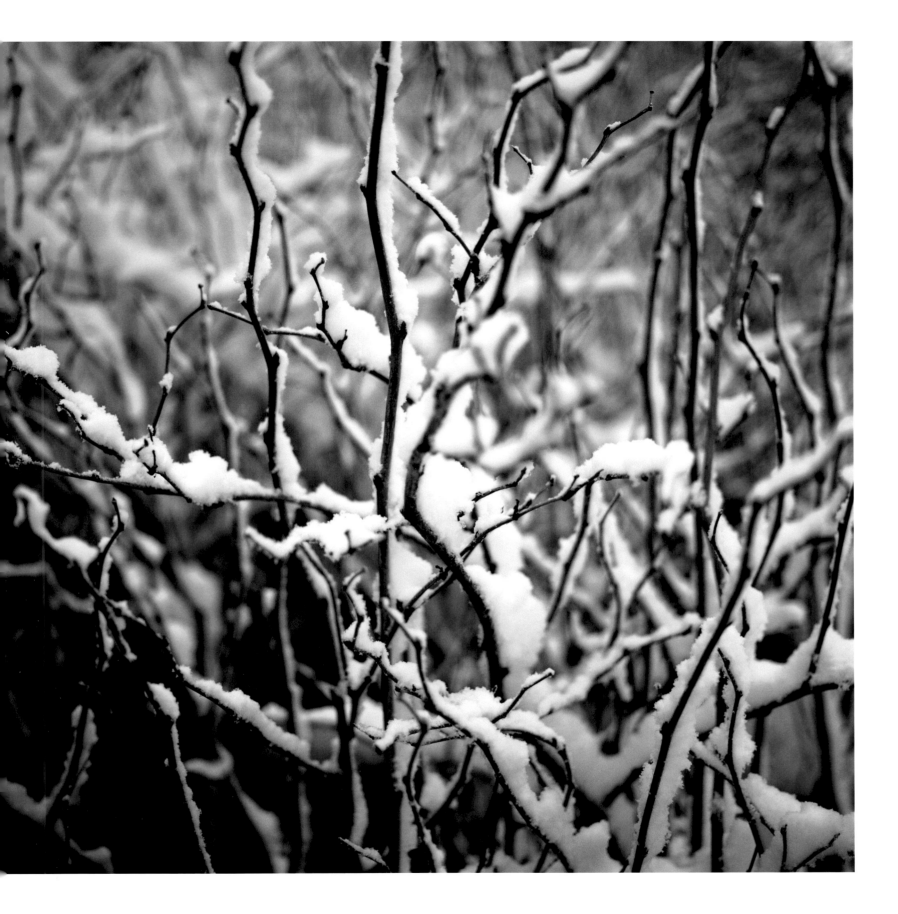

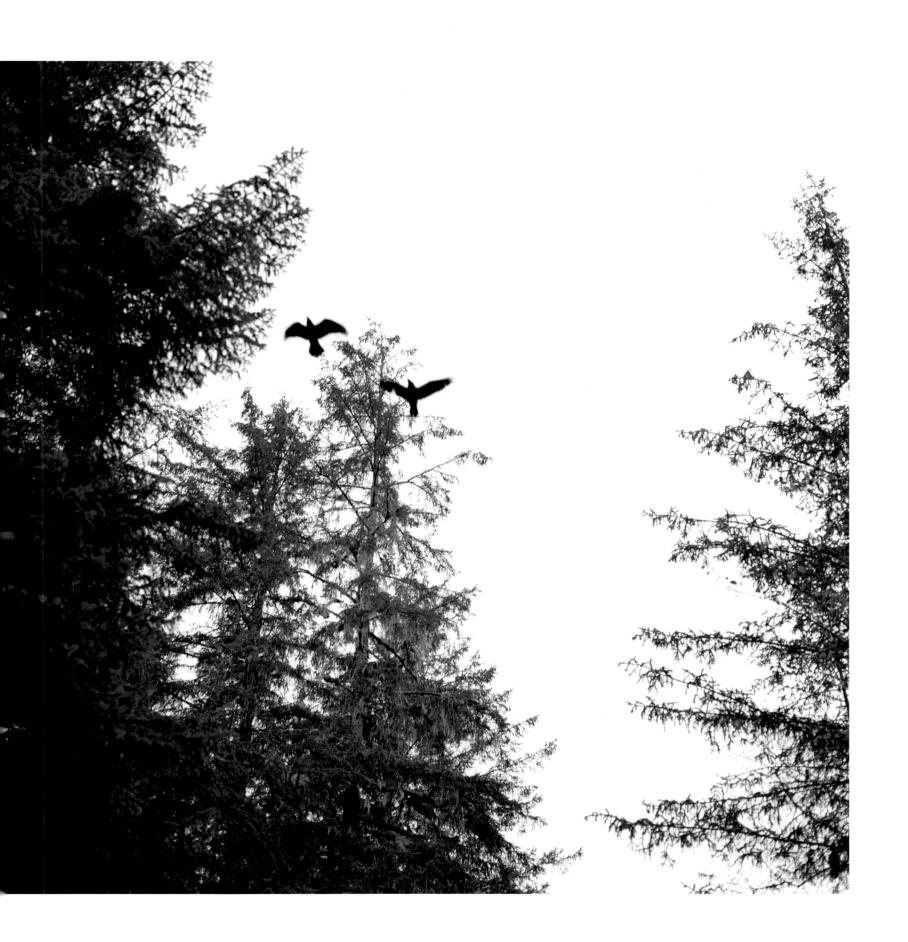

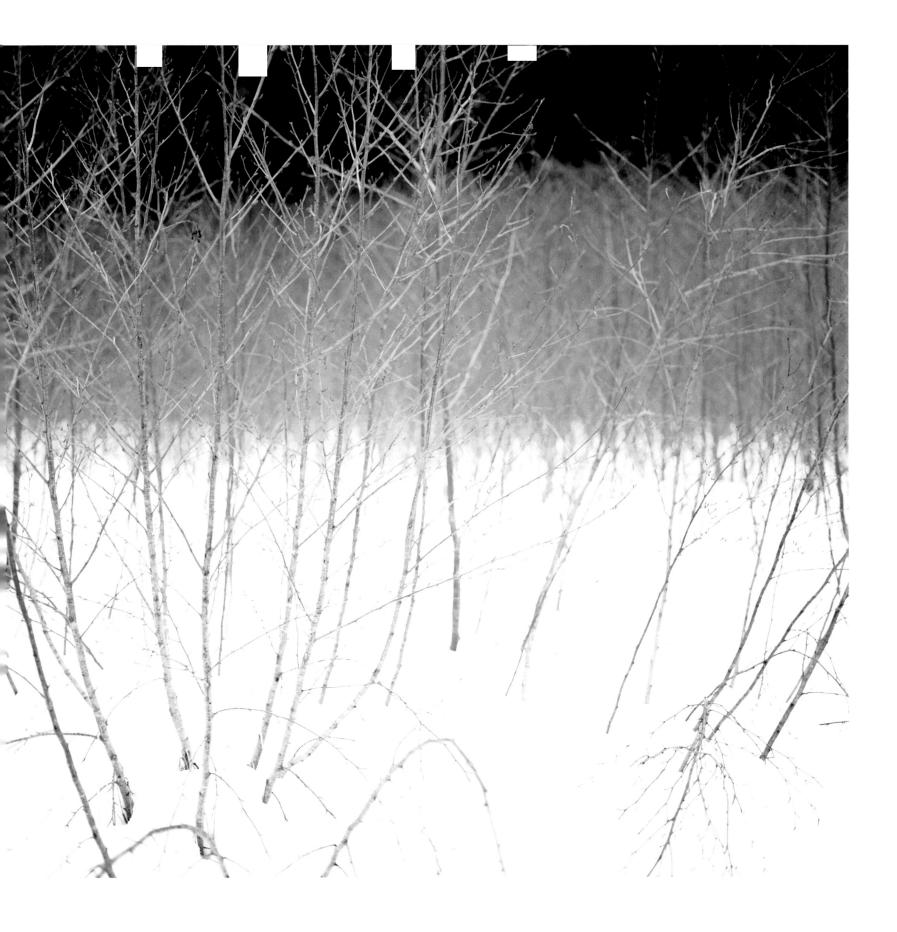

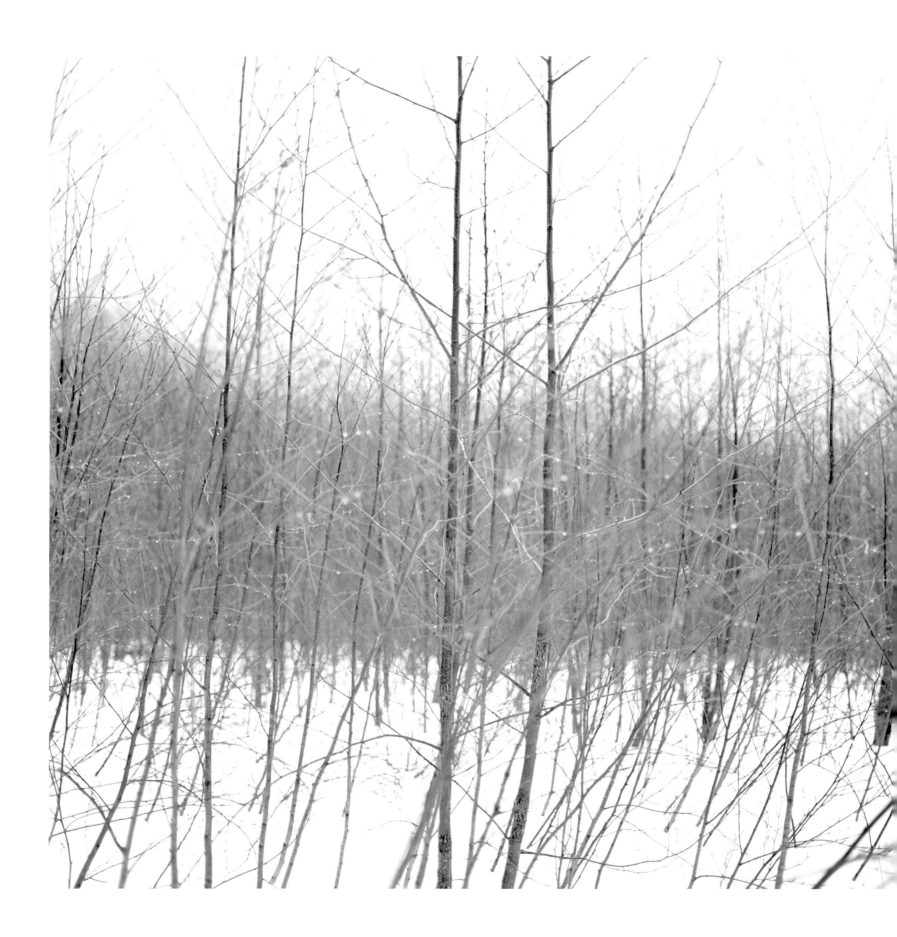

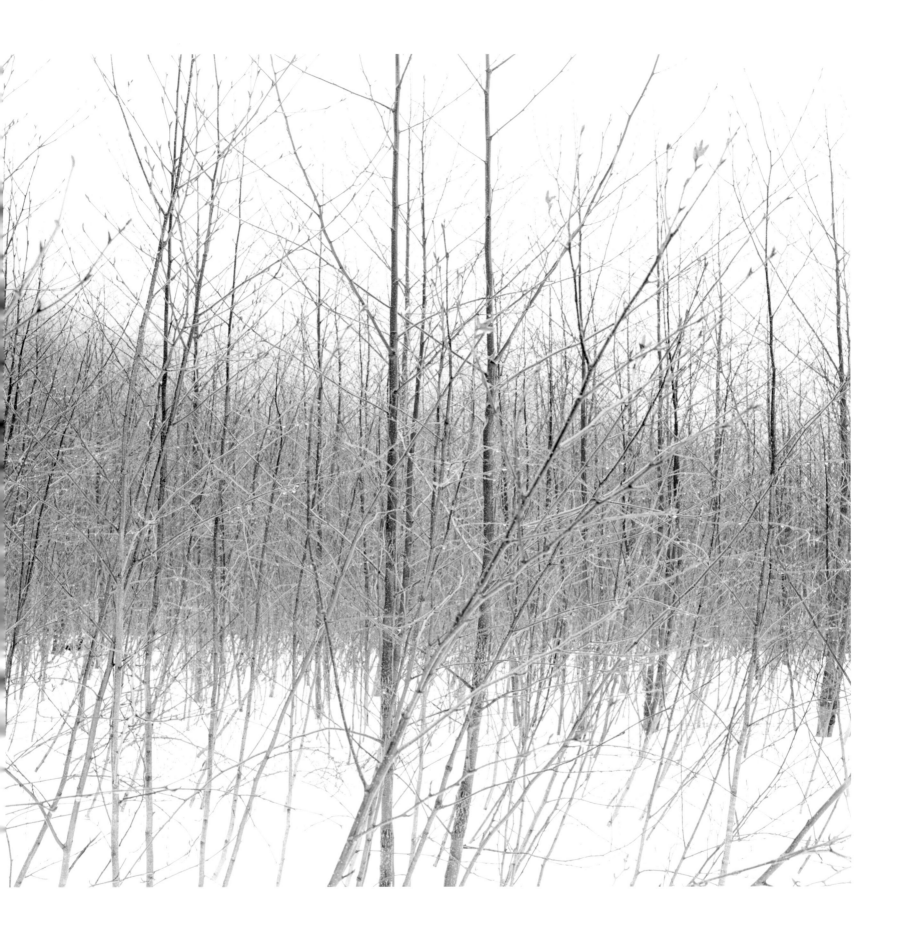

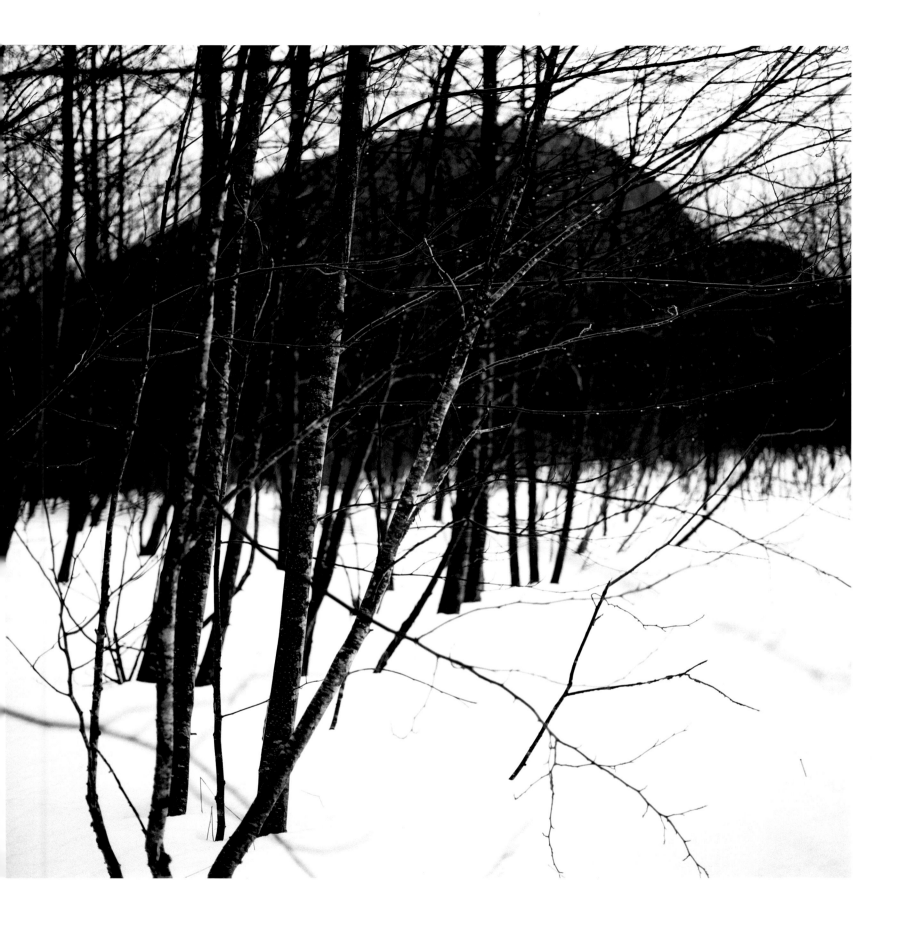

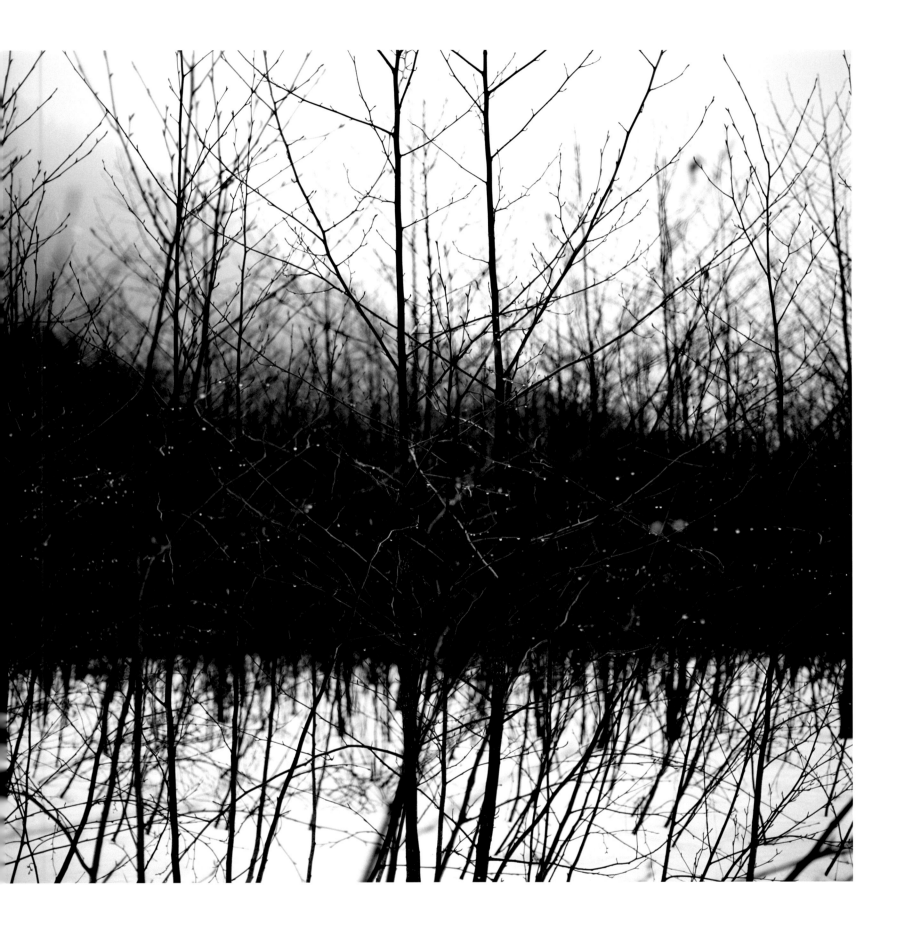

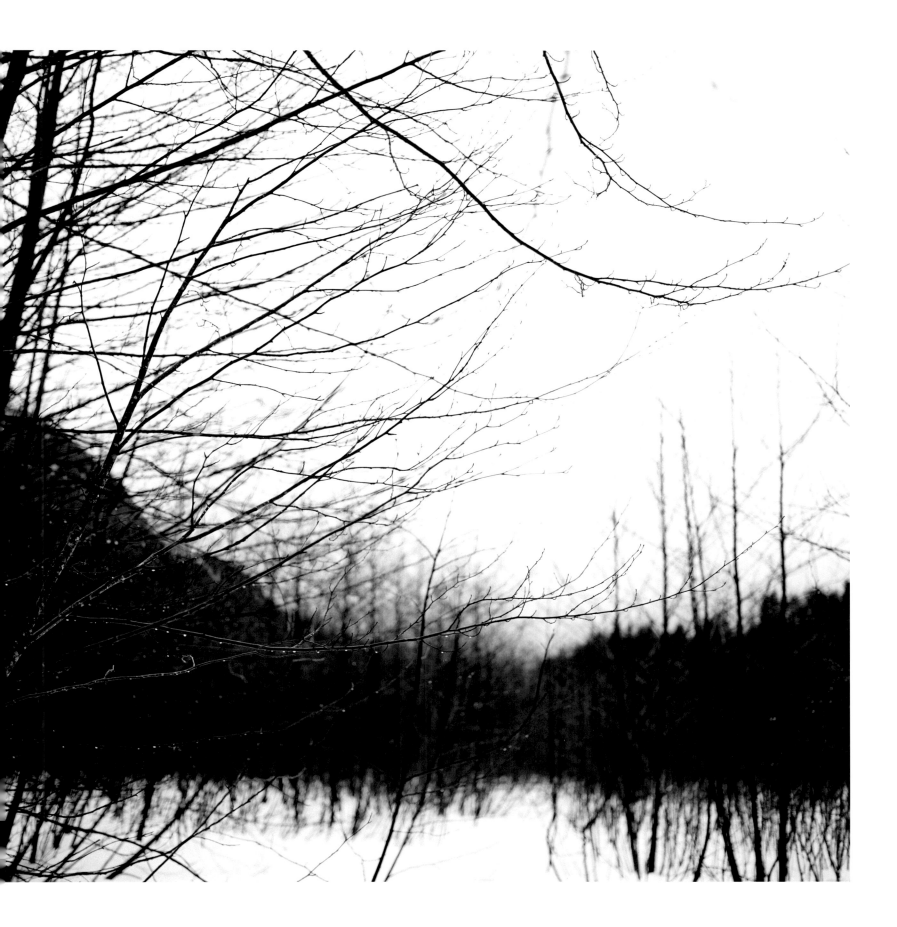

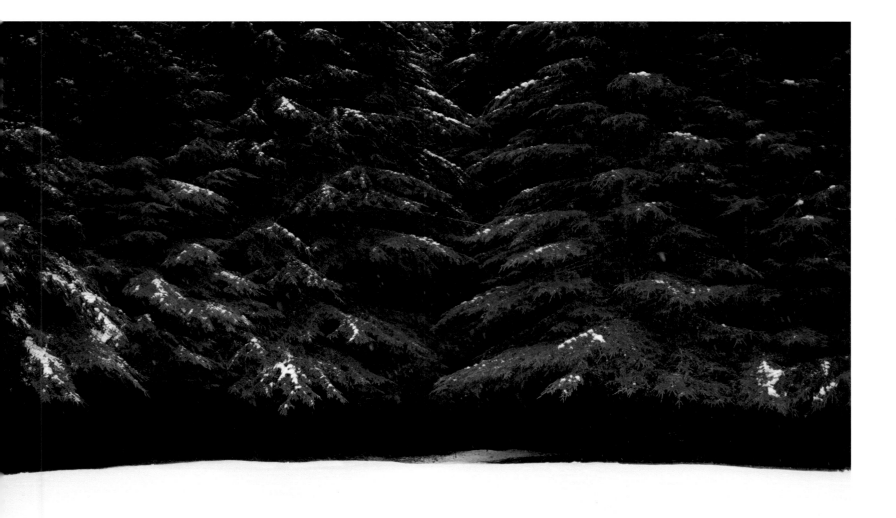

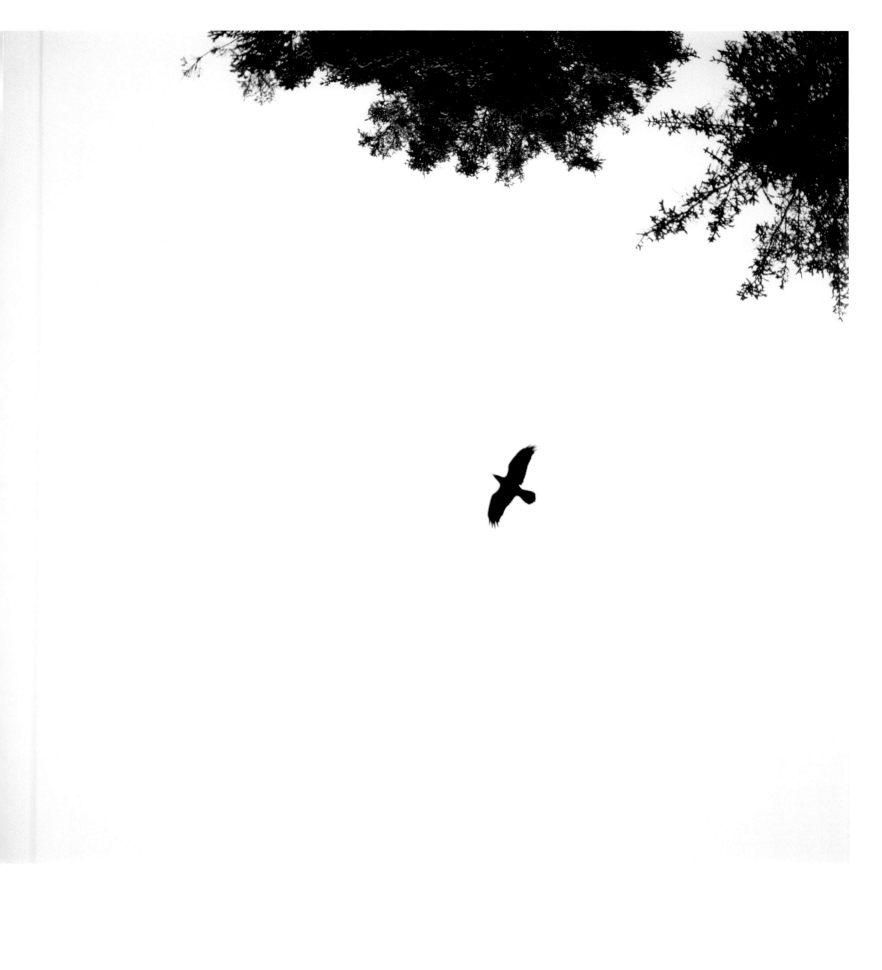

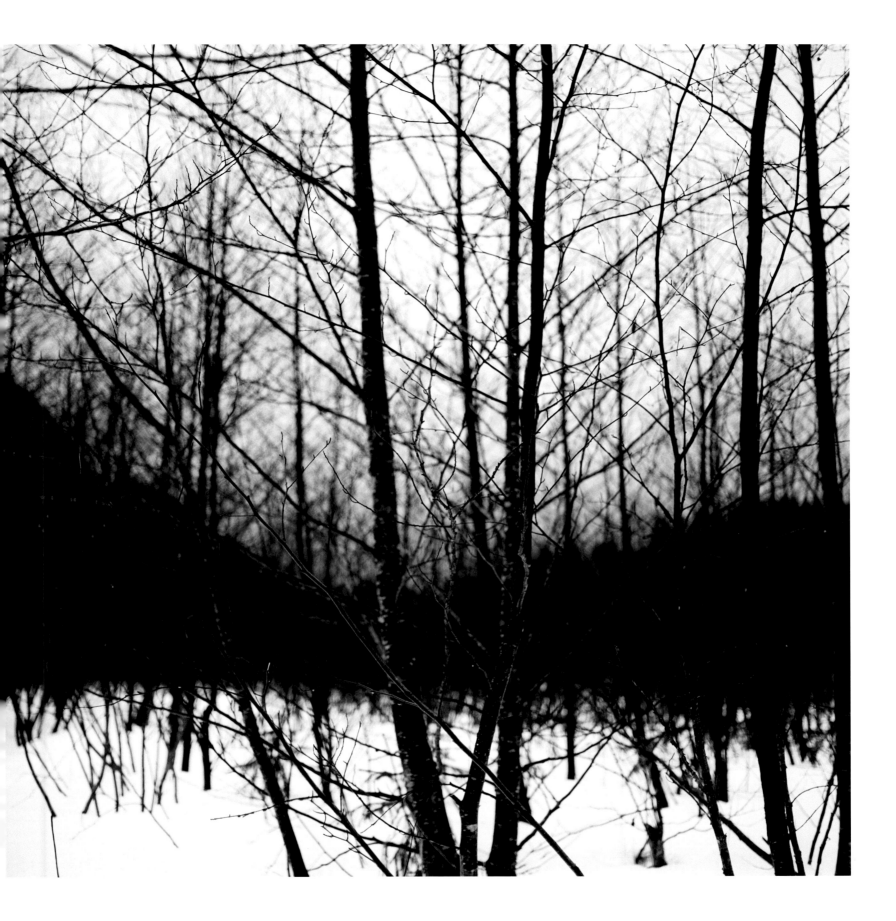

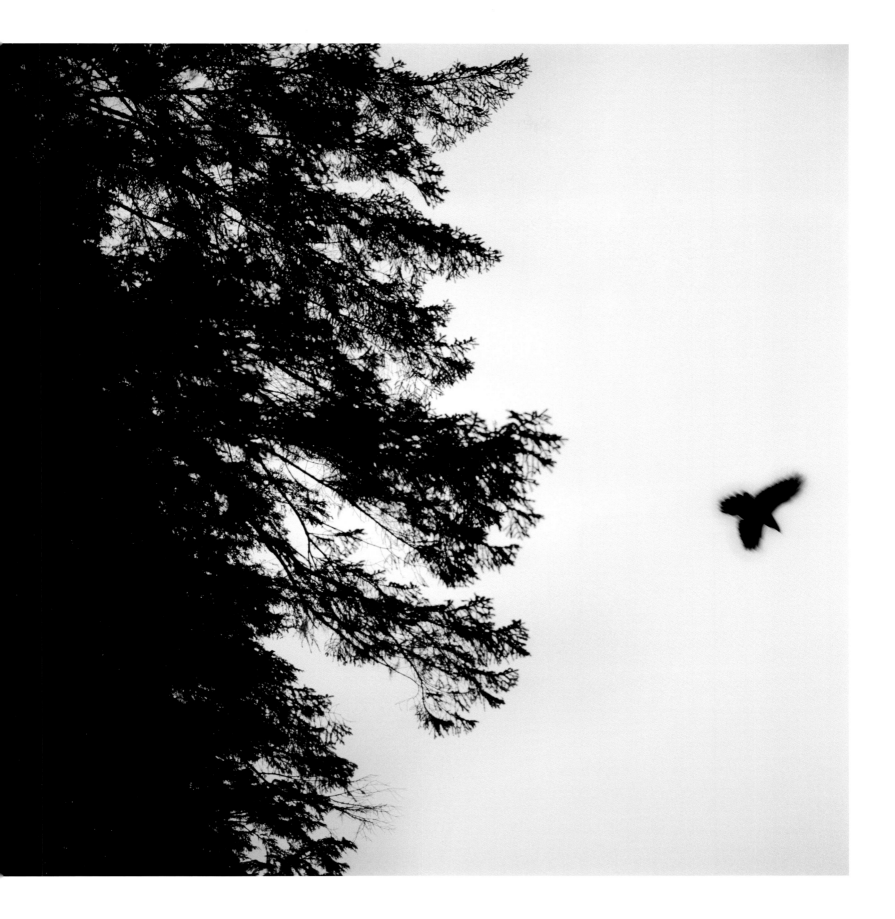

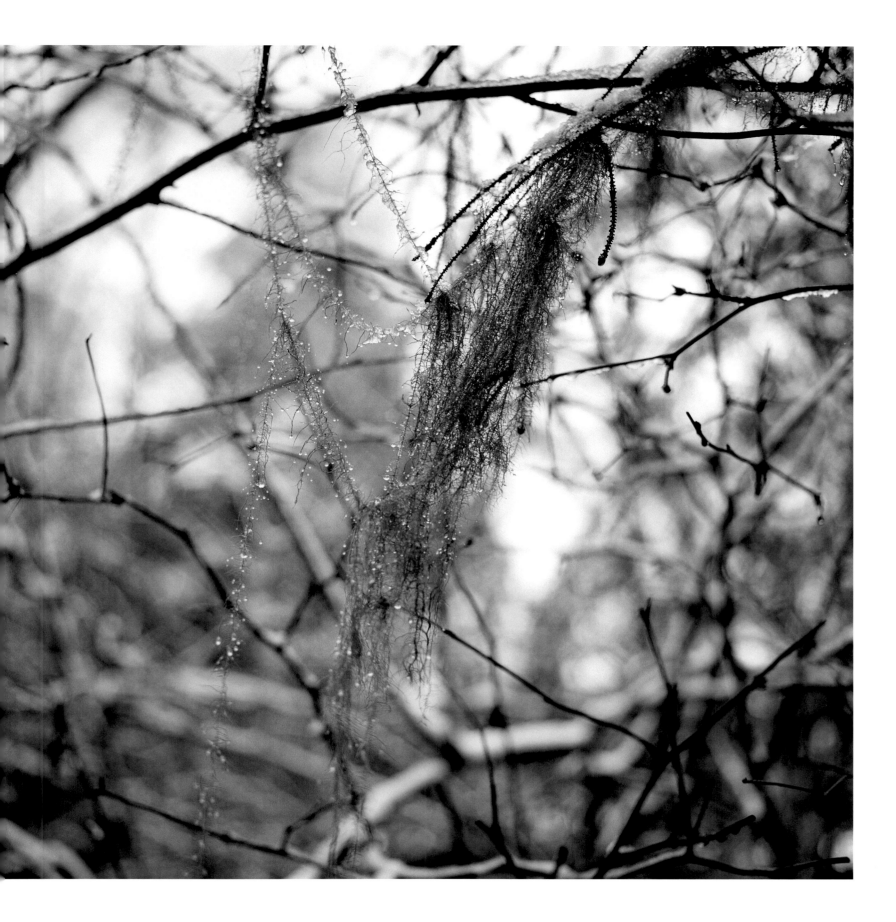

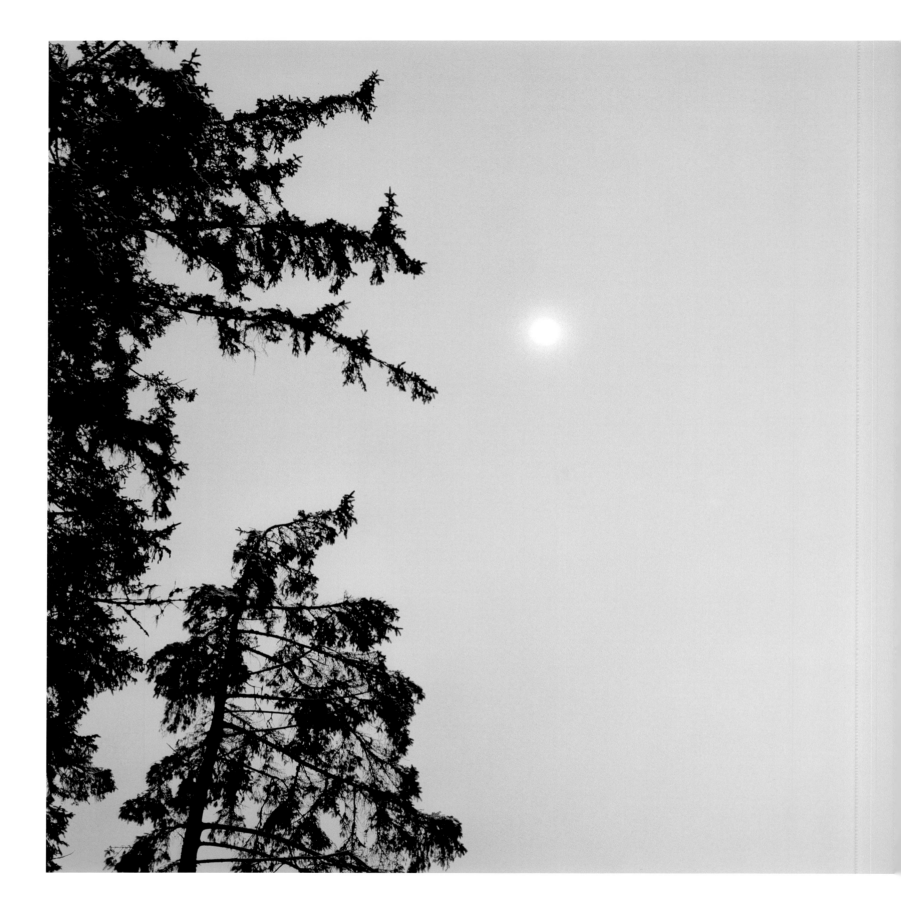

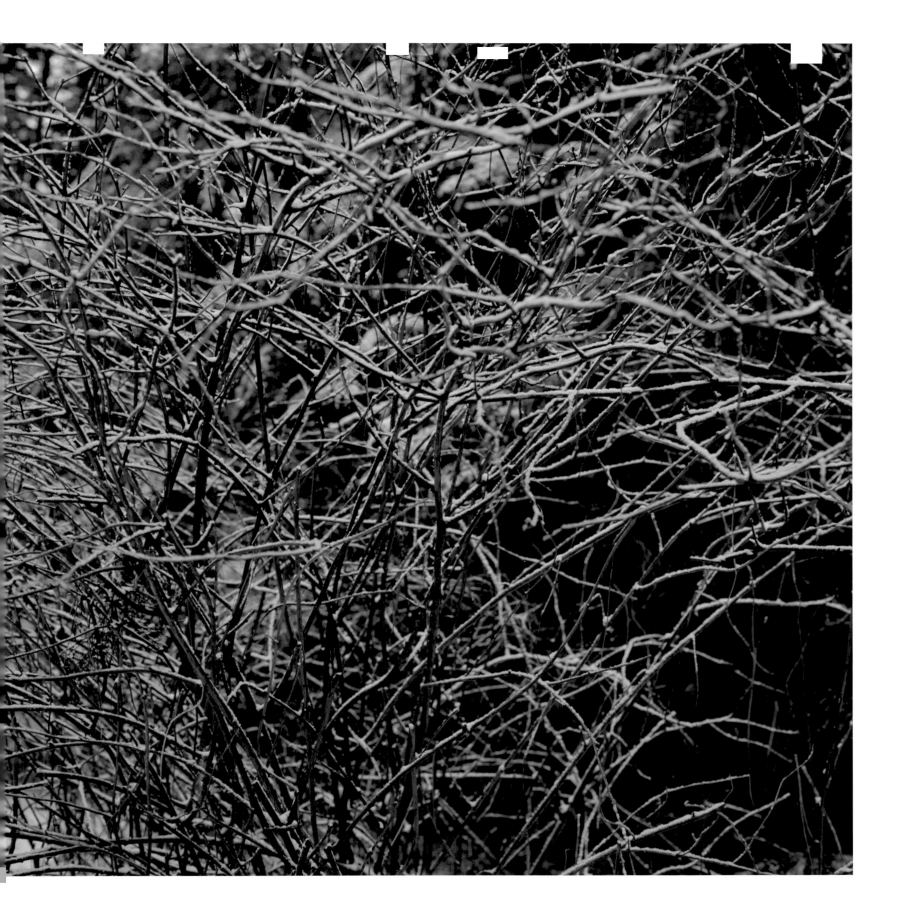

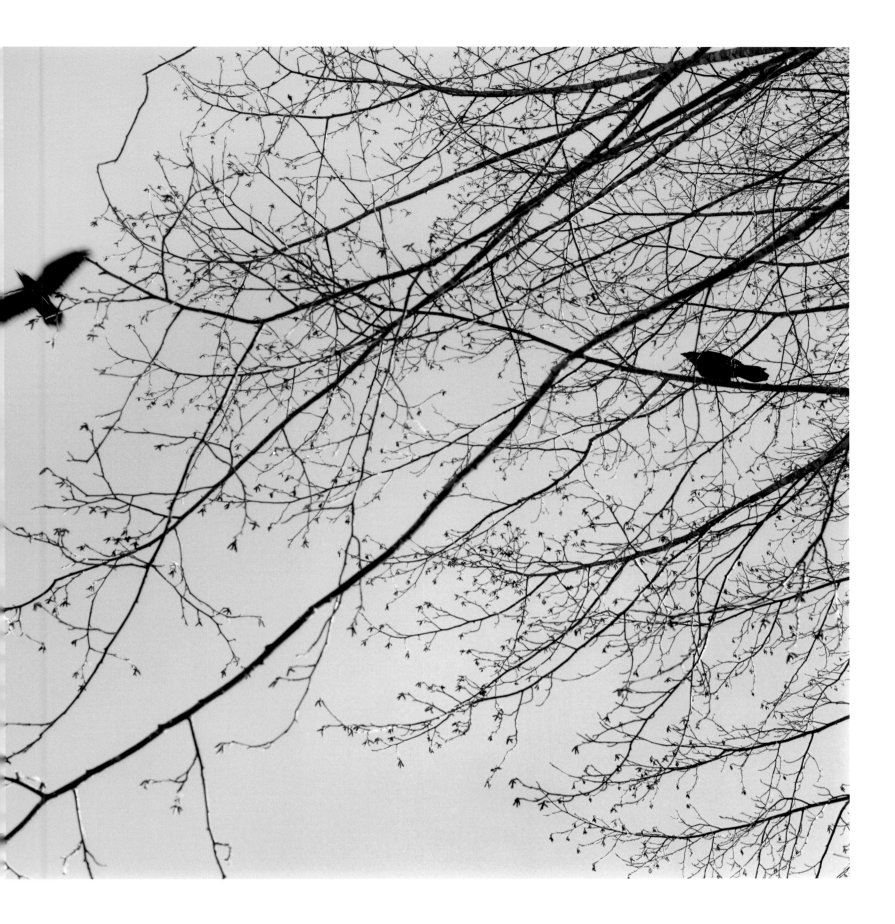

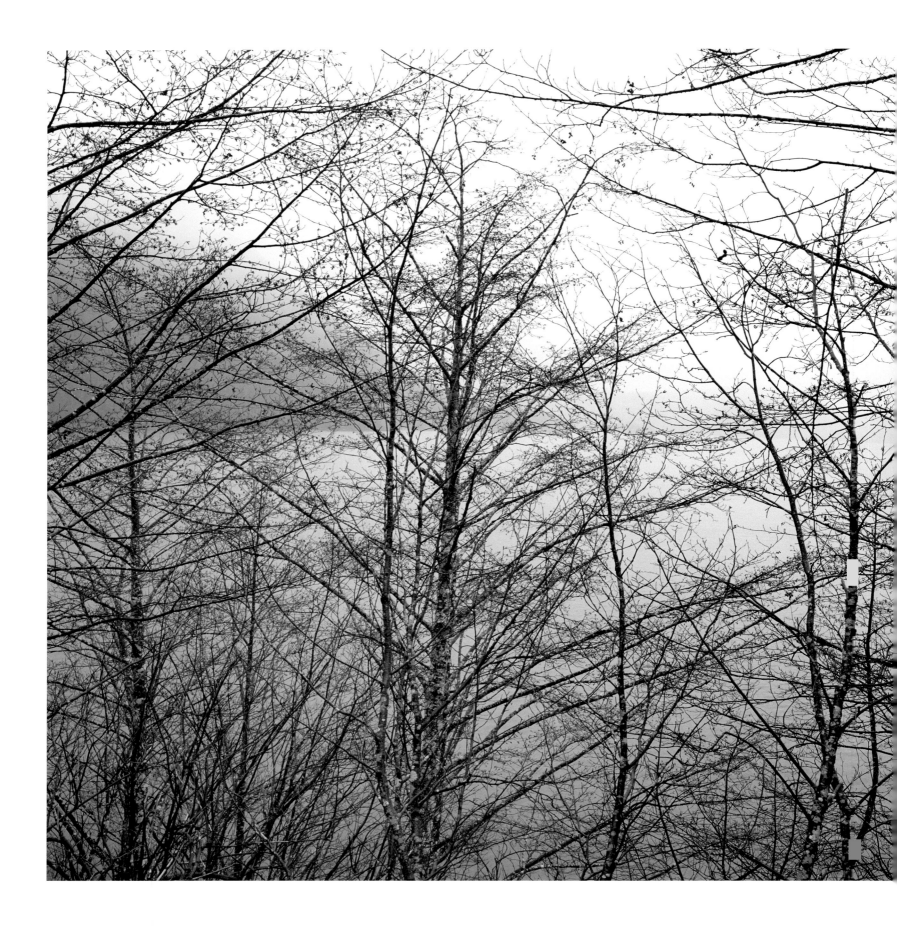

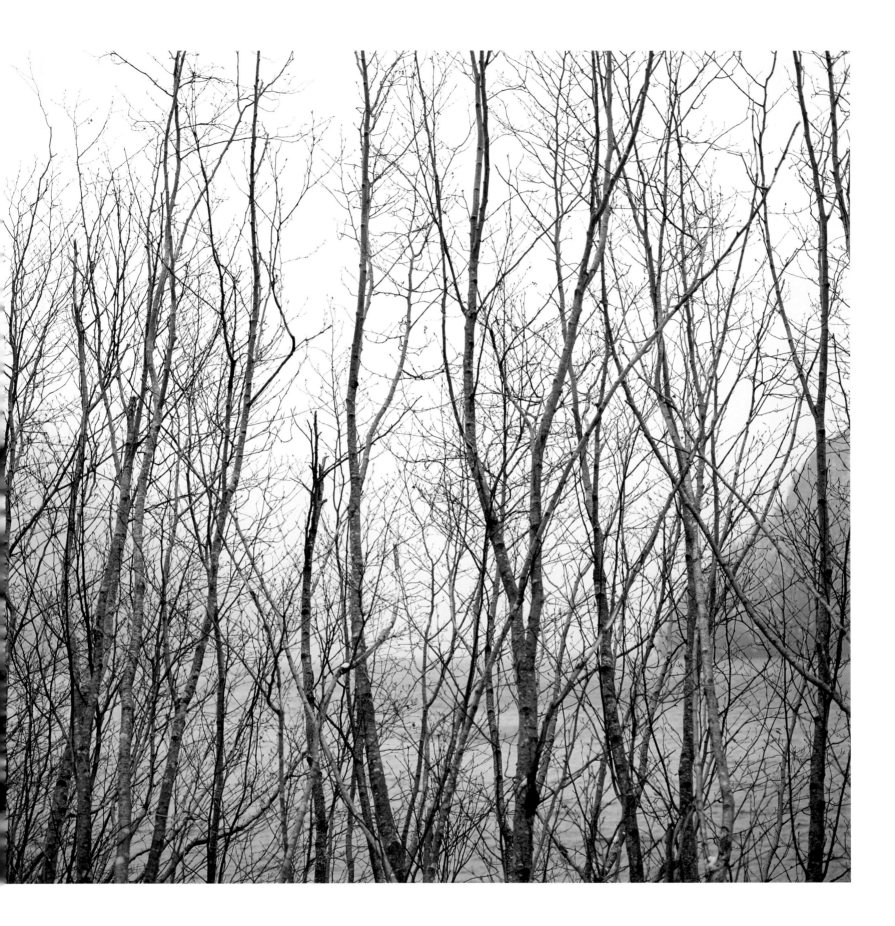

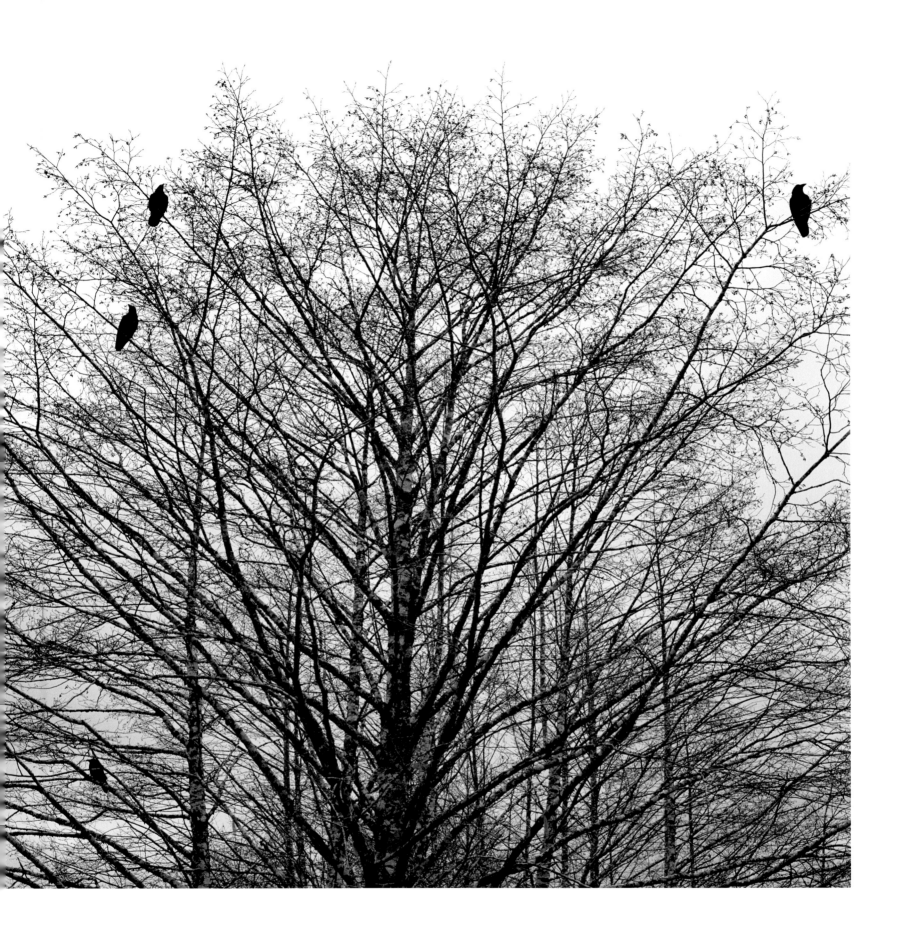

43

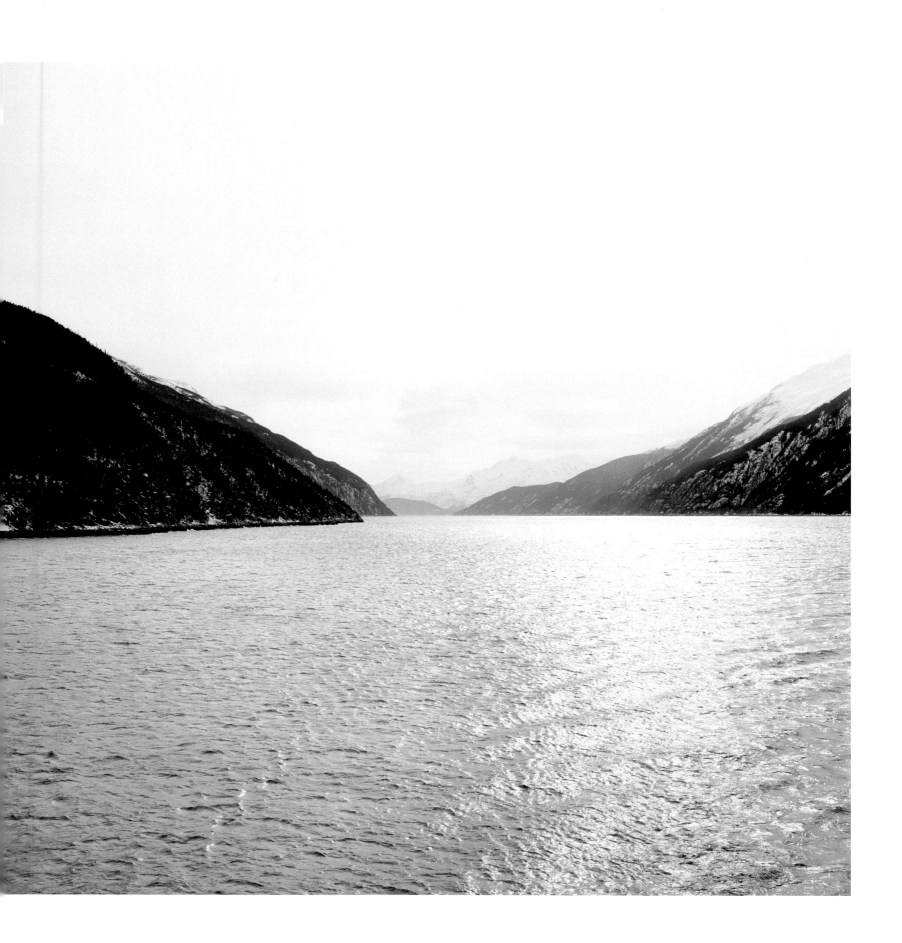

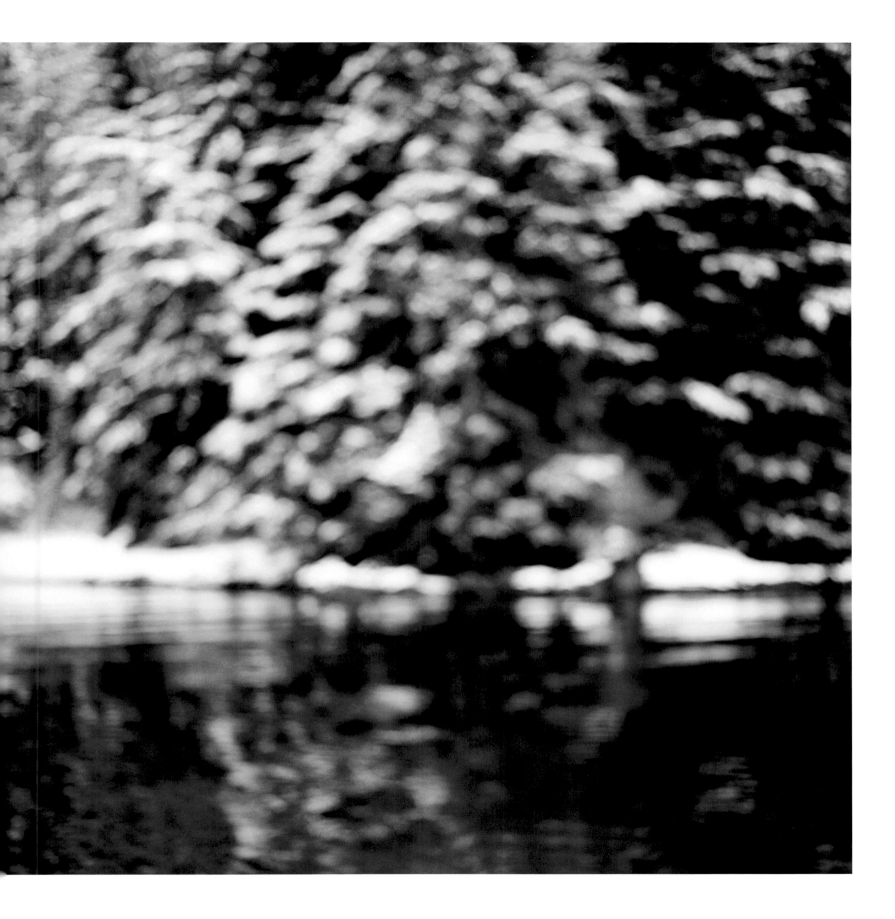

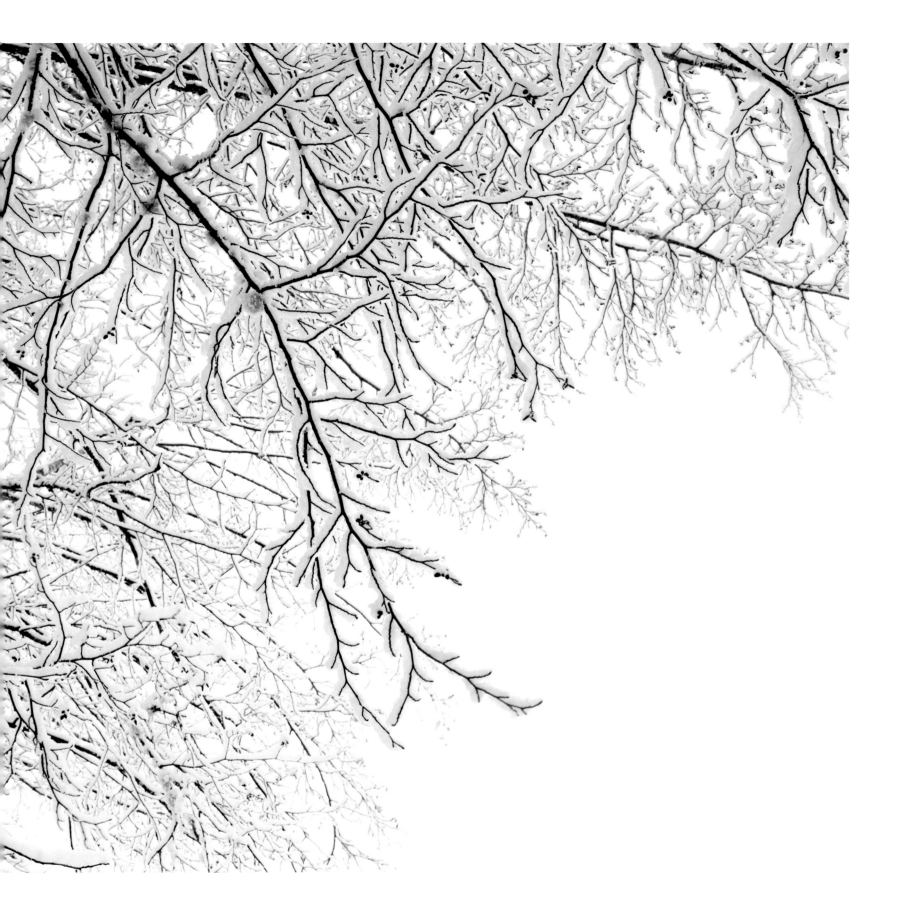

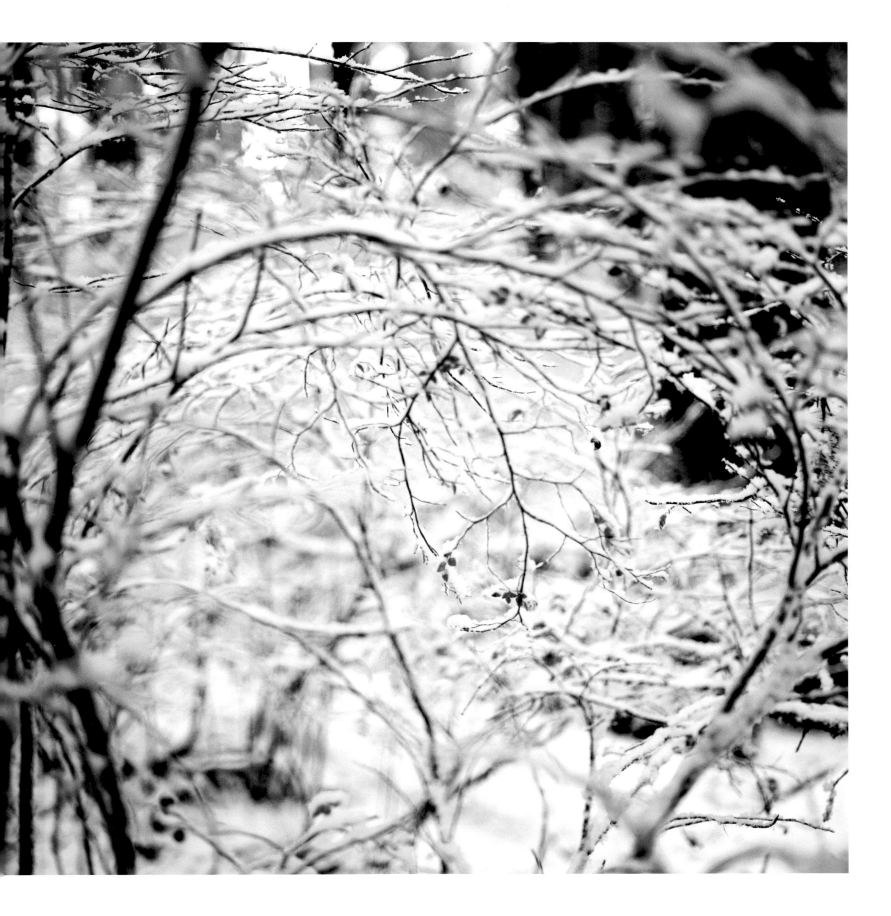

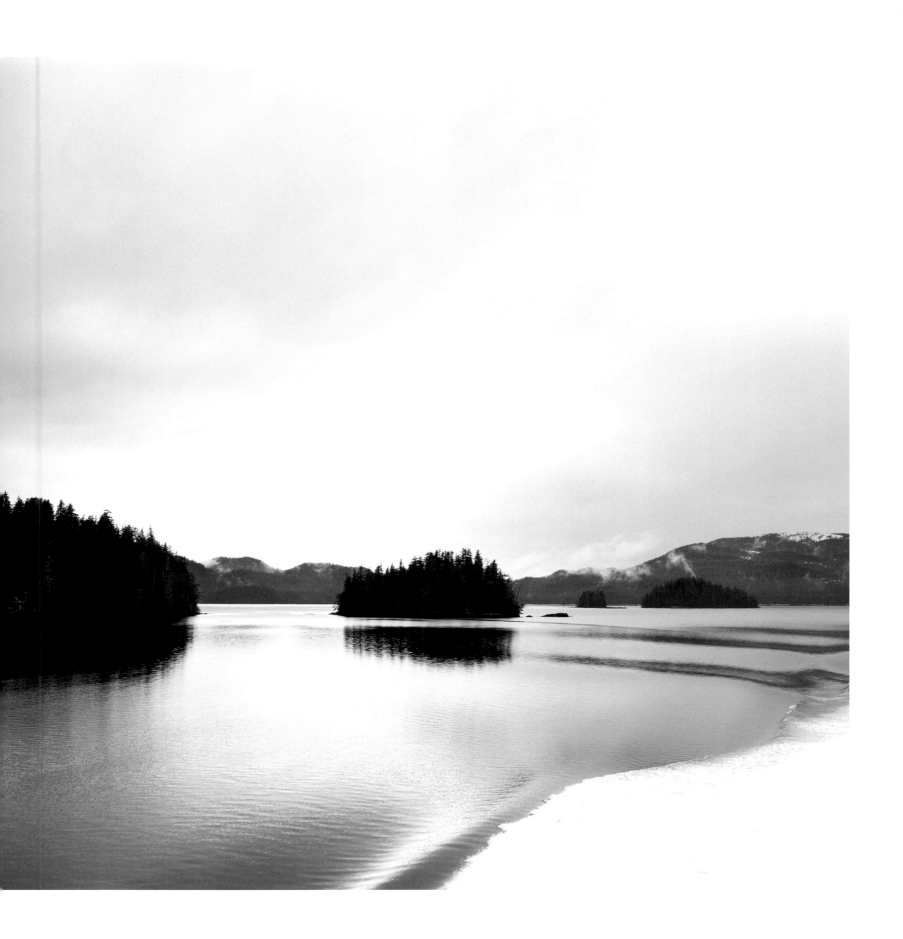

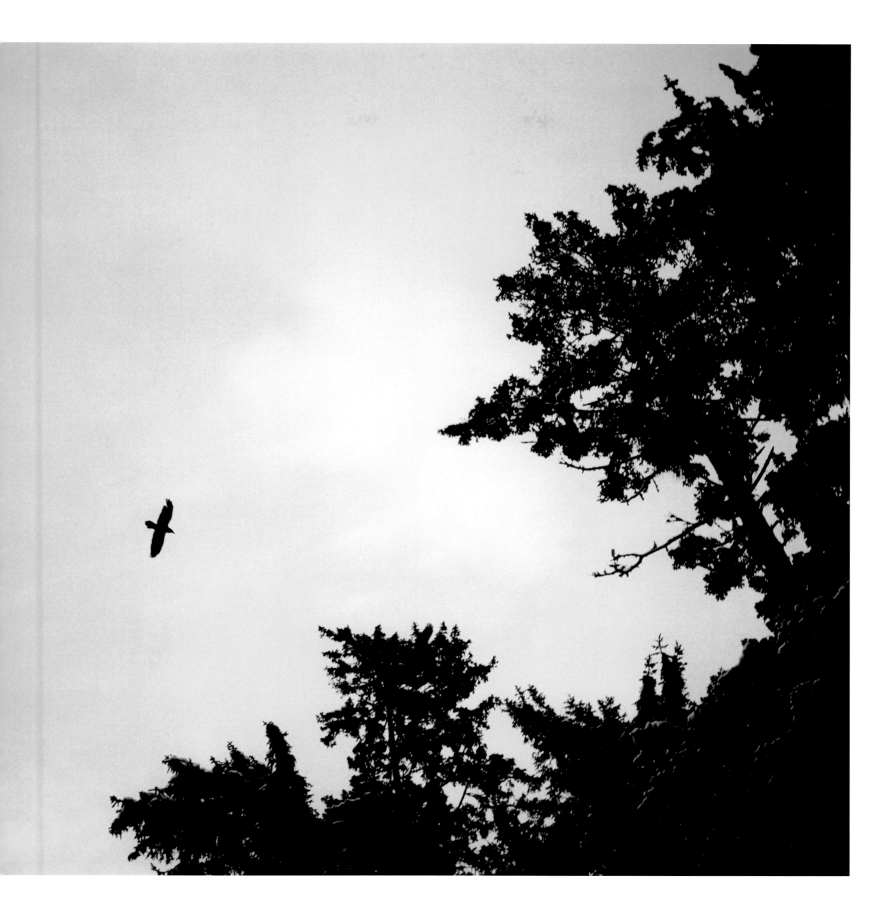

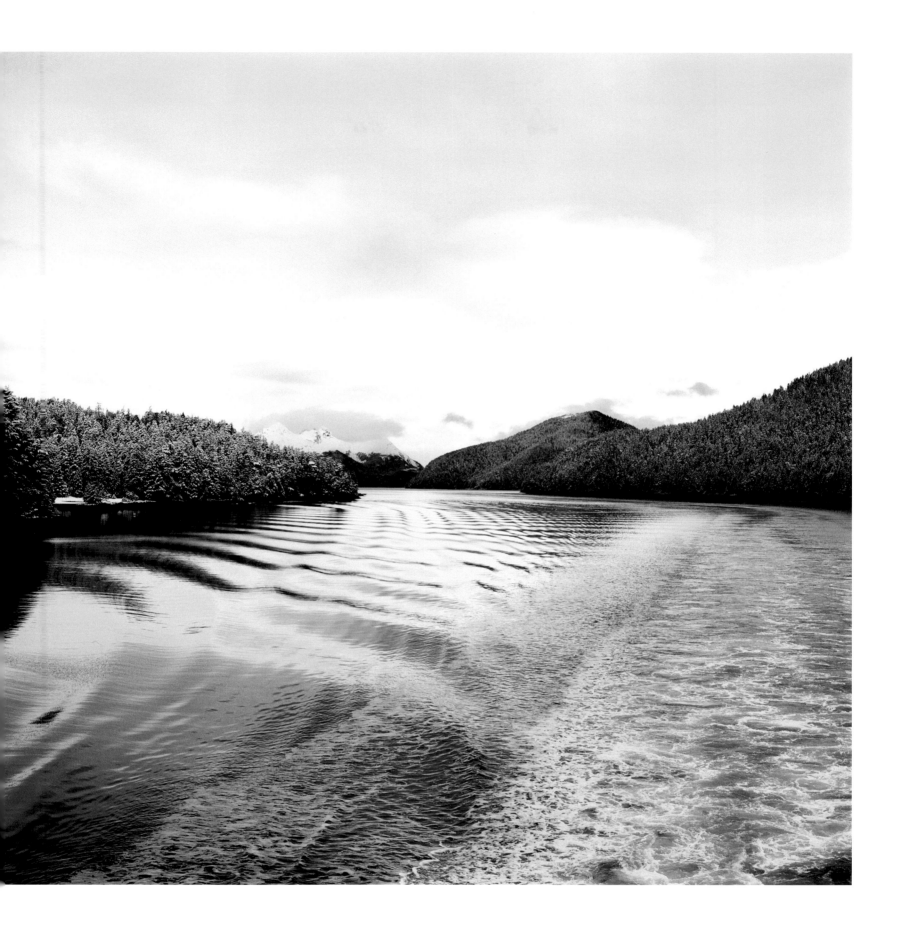

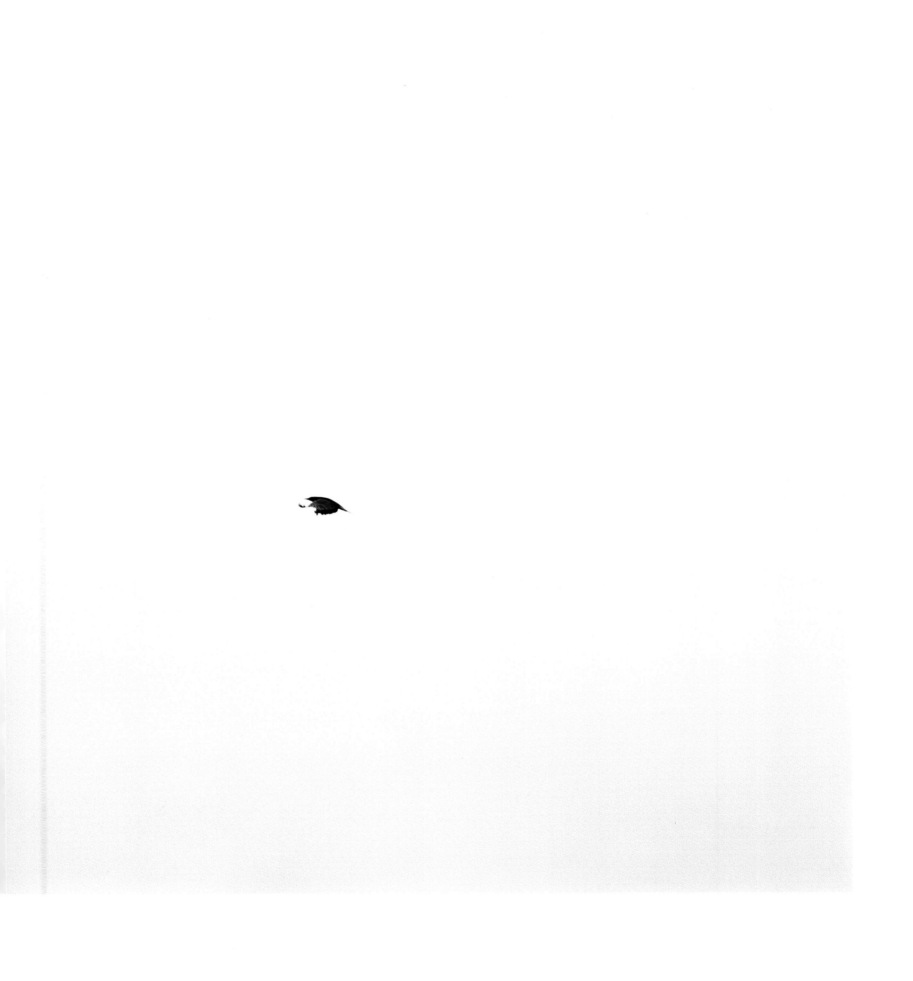

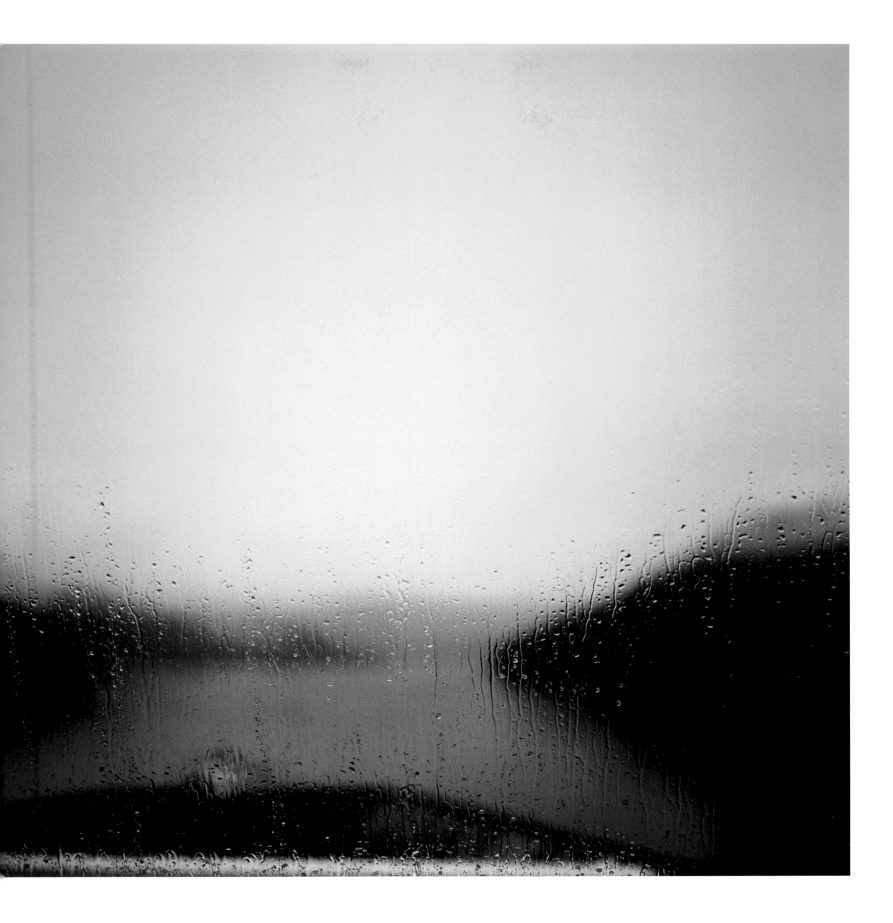

THE WILDERNESS ACT (1 9 6 4

IN ORDER TO ASSURE THAT AN INCREASING POPULATION, ACCOMPANIED BY EXPANDING SETTLEMENT AND GROWING MECHANIZATION, DOES NOT OCCUPY AND MODIFY ALL AREAS WITHIN THE UNITED STATES AND ITS POSSESSIONS, LEAVING NO LANDS DESIGNATED FOR PRESERVATION AND PROTECTION IN THEIR NATURAL CONDITION, IT IS HEREBY DECLARED TO BE THE POLICY OF THE CONGRESS TO SECURE FOR THE AMERICAN PEOPLE OF PRESENT AND FUTURE GENERATIONS THE BENEFITS OF AN ENDURING RESOURCE OF **WILDERNESS.** FOR THIS PURPOSE THERE IS HEREBY ESTABLISHED A NATIONAL WILDERNESS PRESERVATION SYSTEM TO BE COMPOSED OF FEDERALLY OWNED AREAS DESIGNATED BY THE CONGRESS AS "WILDERNESS AREAS," AND THESE SHALL BE ADMINISTERED FOR THE USE AND ENJOYMENT OF THE AMERICAN PEOPLE IN SUCH MANNER AS WILL LEAVE THEM UNIMPAIRED FOR FUTURE USE AND ENJOYMENT AS WILDERNESS, AND SO AS TO PROVIDE FOR THE PROTECTION OF THESE AREAS, THE PRESERVATION OF THEIR WILDERNESS CHARACTER, AND FOR THE GATHERING AND DISSEMINATION OF INFORMATION REGARDING THEIR USE AND ENJOYMENT AS WILDERNESS; AND NO FEDERAL LANDS SHALL BE DESIGNATED AS "WILDERNESS AREAS" EXCEPT AS PROVIDED FOR IN THIS ACT OR BY A SUBSEQUENT ACT.

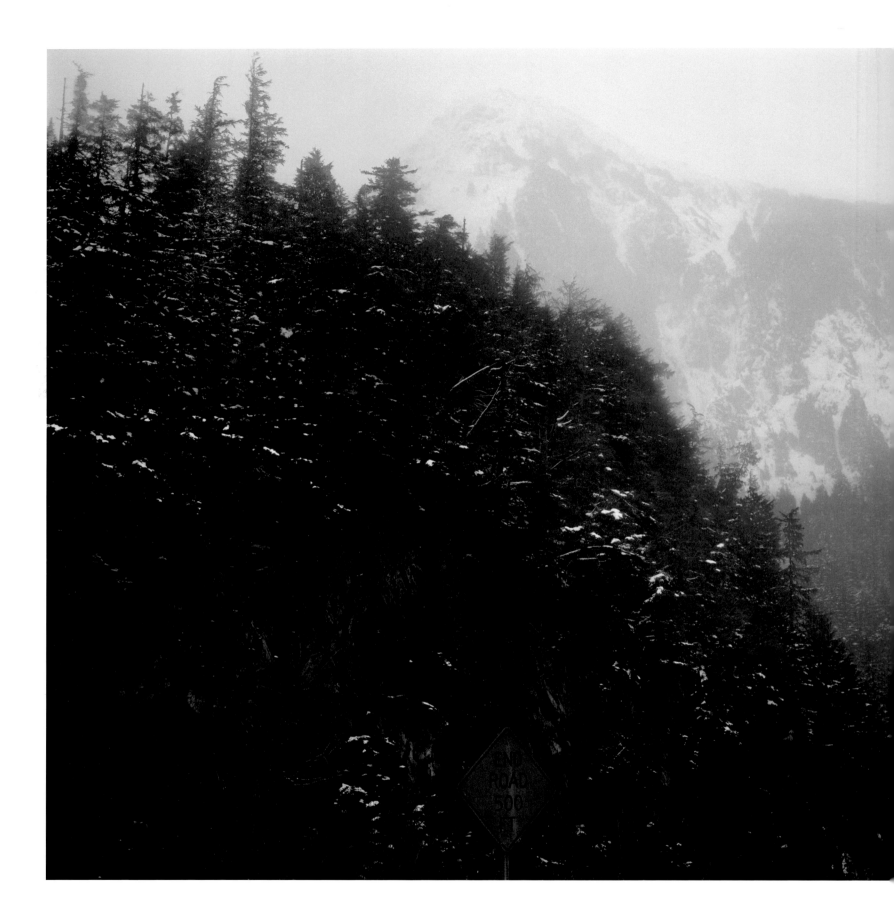

Lauren E. Oakes

HERE WE DRAW LINES:

POLICY

AND

WILDERNESS

Wilderness. Untrammeled. Primeval. Natural. Undeveloped. Unconfined. Protected.

These pertinent, poetic words turned a whole history of human experience into designated places with the passage of the Wilderness Act on September 3, 1964. Romantics once fell in love with the wild, natural world. Settlers cut roads and conquered it. Scientists and philosophers alike struggled to define it. Biologists and leading activists Margaret (Mardy) and Olaus Murie traipsed to the far reaches of American lands to document it and to push for its protection. In 1935, eight conservationists formed the Wilderness Society to fight for wilderness in America.

"Wilderness," as described by Aldo Leopold, "is the raw material out of which man has hammered the artifact called civilization."[1] It took 18 hearings and 66 revisions, years of crafting language in compromise, to create the policy. The U.S. government drew lines across our lands to protect specific areas. It set aside 9.8 million acres of Forest Service land. Yet those lands marked only a beginning. Today, half a century later, there are nearly 800 Wilderness areas encompassing roughly 110 million acres of land managed by four agencies: the U.S. Forest Service, the National Park Service, the U.S. Fish and Wildlife Service, and the Bureau of Land Management. These protected lands are scattered throughout the entire United States from the southern tip of Florida, to the high mesas of New Mexico, and to the far reaches of Alaska and Hawaii. Some 58 million acres—more than half of America's Wilderness area—lie within the vast, remote State of Alaska, our Last Frontier. Still, the Wilderness Act protects only 5 percent of our nation's land.

Defining wilderness in the letter of the law was no easy task. Howard Zahniser, executive director of The Wilderness Society and primary author of the Act, said that "to know the wilderness is to know a profound humility, to recognize one's littleness, to sense dependence and interdependence, indebtedness, and responsibility."[2] Protecting wilderness required an understanding of the trade-offs. Setting aside land for the "preservation of wilderness character" and "the use and enjoyment of the people" meant other uses could be restricted. Commercial outfitters wanted access to wilderness and argued they would allow more people to experience it. Miners defended their existing claims. Ranchers wanted grazing rights. Certain types of energy development remained in question, but wilderness, as a concept and entity that could be protected in place, stood at the core of the legislation. So "wilderness" became "Wilderness" with a capital "W" in law.

In legislation, Wilderness emerged as:

an area where the earth
and its community of life
are untrammeled by man,
where man himself is a visitor
who does not remain . . .
an area of undeveloped Federal land retaining
its primeval character and influence,
without permanent improvement
or human habitation,
which is protected and managed
so as to preserve its natural conditions
and which generally appears to have been affected
primarily by the forces of nature,
with the imprint of man's work substantially unnoticeable,
has outstanding opportunities for solitude
or a primitive and unconfined type of recreation . . .
may also contain
ecological,
geological,
or other features
of scientific,
educational,
scenic,
or historical
value. [3]

Poetry is born from a place of passion.

Inspired by concerns for the wild in the face of population growth and westward expansion, Wilderness became the h... est level of preservation our nation could offer. It remains so today, raising standards on lands designated as Wilderness ev... within the National Park Service. Cars may carry visitors from one lookout point to another on National Park lands. Park S... vice managers may pave roads for easier access or construct buildings for the public. But designate an area as Wilderness, a... then everything that defines wilderness character becomes the primary resources to be protected. Motorized transportati... occurs only if it helps the perpetuation of Wilderness. Structures erected prior to designation may stay standing or in so... cases, Wilderness managers remove them along with the other remnants of human history. People access deep Wilderness...

foot or horse—the "primitive" means. The law never required that a politician or a scientist recognize what's wild. People fight for what they love. Any citizen or group can propose a Wilderness designation to a member of Congress. Advocates continue to push for more.

Unlike any other designation, Wilderness distinguishes an approach to management that minimizes interference with plants, animals, soils, water bodies, and natural processes. It lets nature take its course. It is based on the fundamental conviction that some places deserve a limited hand of control and that we, as humans—a species seemingly separate from these places—have something to gain from experiencing them or simply knowing they exist. Yet critics of the Wilderness ideology trace the history of some lands back to the removal of Indian people from territories like Yosemite Valley.[4] In a genocide of western expansion, some argue our nation erased a history of human presence by designating such places as National Parks and later as Wilderness. "Only people whose relation to the land was already alienated could hold up wilderness as a model for human life in nature," critiqued historian William Cronon, "for the romantic ideology of wilderness leaves precisely nowhere for human beings actually to make their living from the land."[5] Others believe there was never this distinct dichotomy between humans and nature in the Wilderness Act. Zahniser's careful selection of the word "untrammeled" emphasizes a place unbounded by human control; the untrammeled naturalness of wilderness doesn't mean humans are absent.[6] Culture and nature coexist. Wilderness areas provide the places for people to reconnect to nature.

In 1960, Wallace Stegner sent a letter to the Outdoor Recreation Resources Review Committee, a letter later to be known in our history as "The Wilderness Letter." He wrote, "We simply need that wild country available to us, even if we never do more than drive to its edge and look in. For it can be a means of reassuring ourselves of our sanity as creatures, as part of the geography of hope."[7] Today, we are learning that even the untrammeled, undeveloped, and unconfined is changing. We can't condone our choices for the other 95 percent of our nation's land by simply putting aside the primeval. The wilderness we need may exceed the Wilderness in our nation.

With the definition of Wilderness as written in law, our government placed that poem on the land and asked generations following to interpret it best. Wilderness began with the notion of preserving the idealized nature for the use and enjoyment of our people. It evolved, only a decade later through new wilderness laws, to include forests that were once logged.[8] Some wild places could be restored with time and set free as Wilderness too. There have been other amendments to the Act since its passage. At times, oil and gas and other industries have asked to be granted access to Wilderness. Just like the artists and the poets, the policymakers and the agencies must constantly reshape our understanding of Wilderness.

Human impact in some of our most remote Wilderness areas is no longer only about immediate impacts and the footprint. Understanding the changes resulting from a global economy demands a new recognition that "the imprint of man's work" can be displaced from one place on our planet to another.

Preservation was once conceived in opposition to development or direct uses like forests cut for timber or pipes built for oil. Now planes flying high above interrupt the chatter of a raven. Boat traffic along the coastal waters of Wilderness land degrades a sense of solitude. Wind patterns blow air pollutants from intense agricultural production or the burning of fossil fuels thousands of miles away. Accumulation of greenhouse gases from a consumption-based society drives climate change. Stream temperatures rise or snow falls as rain, and habitat is no longer suitable for vulnerable species. The ocean tide rolls in and leaves behind debris from hands that never "touched" that Wilderness land. These kinds of far-flung impacts are indifferent to land designations.

Just leaving these places alone isn't possible anymore. Some argued it never was. No lines drawn can build a fortress preservation. Without monitoring, agencies can't know how these places are changing. Without measuring, they can't make comparisons. Our government created another resource in policy: Wilderness. And just like any other resource people utilize, just like any other resource that people want to endure, we must strive for its sustainability. Wilderness came to be through a state of mind.[9] Yet today, with greater awareness of impacts to Wilderness and the trade-offs managers face in balancing its use and preservation, our agencies are working to define Wilderness character and institutionalize ways to measure, to monitor, and maybe even to manage it. Our relationship with Wilderness is evolving yet again. Even in letting nature free, agencies need common tools and touchstones to make the right choices. People now put numbers to what was only once experienced as the natural and taken for granted as abundant. "Primitive," "undeveloped," "natural," and "untrammeled" are all central elements of Wilderness character in legislation, but how do we perpetuate their use and enjoyment and leave the qualities unimpaired? To evaluate change and impacts to solitude or primitive quality, managers measure and monitor the number of trails, the amount of visitor use, or intrusions to the natural soundscape. In emerging, coordinated efforts, people going to experience Wilderness on their own may collect the relevant information for overseeing agencies. To evaluate change and impacts to the natural, managers measure and monitor the effects of climate change, numbers of threatened or endangered species, or glacial retreat.[10] These are not easy tasks.

Managing Wilderness character requires asking complex questions to make difficult decisions. When does a trail harm Wilderness more than it benefits Wilderness? Do we really need signs in the wild? Are we responsible for controlling predators of threatened prey? If a wild fire helps a forest but poses risk to people, do we let it burn? Do we permit scientific study of Wilderness lands to benefit only Wilderness?

Darwin told us long ago that what adapts survives. Setting aside protected lands has long been perceived as progressive conservation, yet the policy itself established a system that required us to conceive of ourselves apart from, rather than "a part" of nature. Wilderness, capital "W," may be law but the goal of wilderness is far more spiritual and inspirational—to find a way to include us. How do we become a part? If some places should be free from the hand of man, free from "management," then only what has the ability to adapt will survive. Separating ourselves from Wilderness, denying the impacts of our actions from afar, means we simply let it all unfold. Some species endure, others lose out. Wilderness was once about letting go. Now we need to hold on.

Just over a decade ago, Nobel Prize–winning scientist Paul Crutzen first suggested that we live in the "Anthropocene," a new geological epoch in which humans are drastically altering the planet.[11] The idea—rather, the reality—is that humans have become the primary force for change on the earth.

We dominate biological, chemical, geological processes by our actions and our patterns of land use change. We move mountains to access mineral deposits. We clear forests for corn. These human impacts on the earth's ecosystems mark the age of Anthropocene.

The moment in time when the Anthropocene, or Age of Man, began is just as hard to define as Wilderness. Geologists scientifically distinguishing any other origin of a particular era in history would typically rely upon fossils. Layers upon layers of rock contain fossils characteristic of Earth during any given time. A shell once deposited at sea now rests on land. Grains of sand blown across dunes once exposed now lay deep in a riverbed. These discoveries explain pathways of change and date early

transformations over millions of years. Now we as humans construct new layers and peel back the ancient ones. To identify the Anthropocene, some propose a distinct boundary evident by the start of the industrial revolution, the agricultural revolution, or the Great Acceleration that embodies the rapid production of new technologies, consumption of fossil fuels, and our growing population since the 1950s. What can we learn inside and between the lines we have drawn for Wilderness?

Together, the lands designated as Wilderness in the fifty-plus years since the Act's passage in 1964 cover an area larger than the state of California. These are the lands we hold to the highest level of protection in our country. "If some Wilderness lands become the refuge for certain species, it's our social responsibility to do what we can to protect that habitat however possible," says ecologist Peter Landres, instrumental in developing a system to institutionalize our monitoring and management of Wilderness character. "In some places that may mean stopping cattle grazing, or hunting, mining, diverting water—the kinds of activities allowed inside wilderness—that may still compromise the habitat of vulnerable species."[12]

A plane traveling above breaks the silence. Thousands of acres of yellow-cedar and aspen trees die in a warming climate. We find spearheads from the Sheep Eaters and pottery sherds from the Hisatsinom, commonly referred to as Anasazi. A glass bottle washes up on the shore of Wilderness. It takes a million years to decay. What fossils do we leave behind? What artifacts will future generations consider as part of nature? By measuring and monitoring changes on these lands, perhaps we can come to a better understanding of our collective impacts in the Age of the Anthropocene. Wilderness depends on more than direct Wilderness management in our nation. These lands may be islands, but together they constitute an oasis of hope. They are barometers of change, and they are speaking for more than Wilderness alone. They are speaking for what remains.

1. Aldo Leopold, "Wilderness," in *A Sand County Almanac and Sketches Here and There* (New York: Oxford University Press, Inc., 1949), 188–200.
2. Zahniser's speech, "The Need for Wilderness Area," is available in Ed Zahniser, ed., *Where Wilderness Preservation Began: Adirondack Writings of Howard Zahniser* (Utica, NY: North Country, 1992), 59–66; see also Mark Harvey, *Wilderness Forever: Howard Zahniser and the Path to the Wilderness Act* (Seattle: University of Washington Press, 2006), 90–92, 200–201.
3. The Wilderness Act, Pub. L. No. 88–577, 16 U.S.C. §§1131–1136 (1964), Section 2(c).
4. For in-depth case studies of three National Parks and the history of Indian removal, see Mark David Spence, *Dispossessing the Wilderness: Indian Removal and the Making of National Parks* (New York: Oxford University Press, 2000).
5. William Cronon, ed., "The Trouble with Wilderness," in *Uncommon Ground: Rethinking the Human Place in Nature* (New York: W.W. Norton & Company, 1995), 69–90.
6. Scott Friskics, "The Twofold Myth of Pristine Wilderness: Misreading the Wilderness Act in Terms of Purity," *Environmental Ethics* 30, no. 4 (2008): 381–88.
7. Wallace Stegner to David E. Pesonen, Wildland Research Center Agricultural Experiment Station, 3 Dec. 1960, in Wallace Stegner, *The Sound of Mountain Water* (Garden City, NY: Doubleday & Company, Inc., 1969), 145–53.
8. The Eastern Wilderness Areas Act designated sixteen new Wilderness areas, many of which had a land use history of logging during early eastern settlement. See Eastern Wilderness Areas Act, Pub. L. No. 93–622, 88 Stat. 2096, 16 U.S.C. §§ 1132 (1975).
9. Historian Roderick Nash explores the topic of changing attitudes toward wilderness and wilderness as a human construct extensively in *Wilderness and the American Mind* (New Haven, CT: Yale University Press, 1967).
10. Peter Landres and Chris Barnes, et al., *Keeping It Wild: An Interagency Strategy to Monitor Trends in Wilderness Character Across the National Wilderness Preservation System*. Gen. Tech. Rep. RMRS-GTR-212 (Fort Collins, CO: U.S. Department of Agriculture, Forest Service, Rocky Mountain Research Station, 2008), 20–28.
11. Paul J. Crutzen and Eugene F. Stoermer "The 'Anthropocene'," *Global Change Newsletter 41* (2000): 17–18.
12. Peter Landres, in discussion with the author, March 24, 2012.

- Bureau of Land Management
- U.S. Fish and Wildlife Service
- U.S. Forest Service
- National Park Service

This journey has deepened

my understanding of

the importance of

continued preservation of

wild places,

which was the passion

and life's work of

Margaret Murie.

—DB, 2013

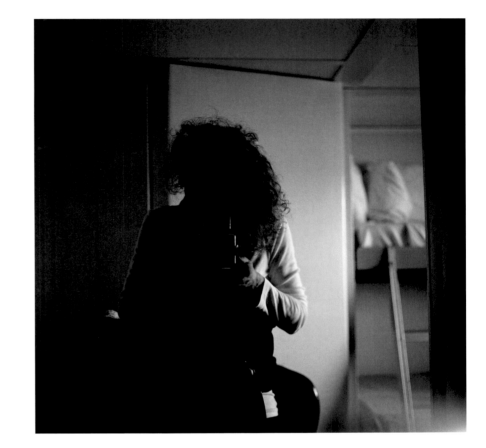

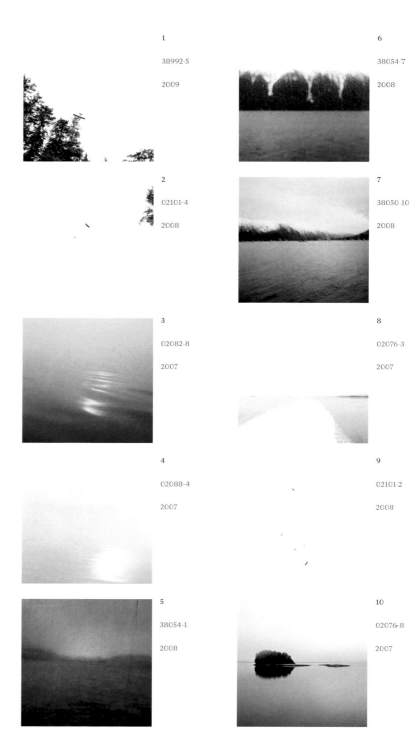

1

38992-5

2009

2

02101-4

2008

3

02082-8

2007

4

02088-4

2007

5

38054-1

2008

6

38054-7

2008

7

38050-10

2008

8

02076-3

2007

9

02101-2

2008

10

02076-8

2007

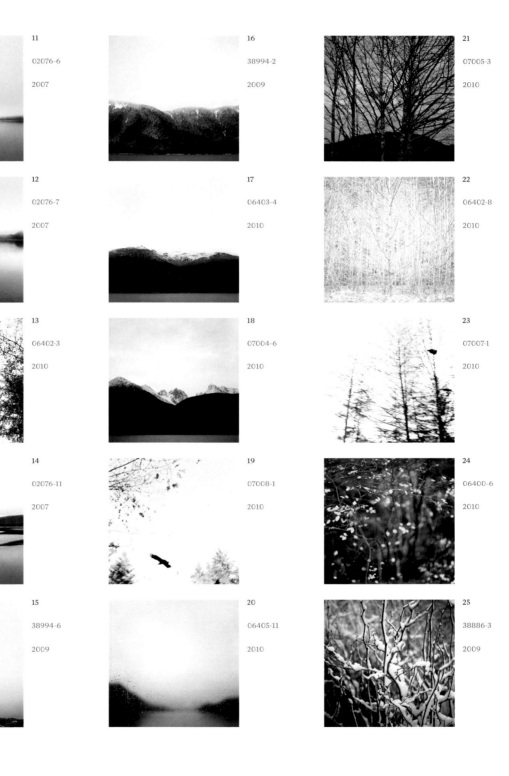

11
02076-6
2007

16
38994-2
2009

21
07005-3
2010

12
02076-7
2007

17
06403-4
2010

22
06402-8
2010

13
06402-3
2010

18
07004-6
2010

23
07007-1
2010

14
02076-11
2007

19
07008-1
2010

24
06400-6
2010

15
38994-6
2009

20
06405-11
2010

25
38886-3
2009

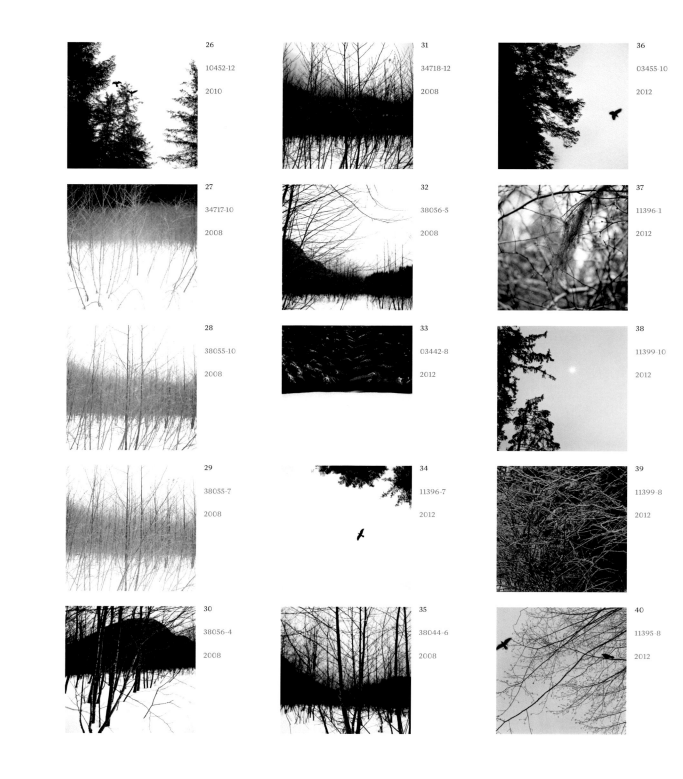

26 10452-12 2010

31 34718-12 2008

36 03455-10 2012

27 34717-10 2008

32 38056-5 2008

37 11396-1 2012

28 38055-10 2008

33 03442-8 2012

38 11399-10 2012

29 38055-7 2008

34 11396-7 2012

39 11399-8 2012

30 38056-4 2008

35 38044-6 2008

40 11395-8 2012

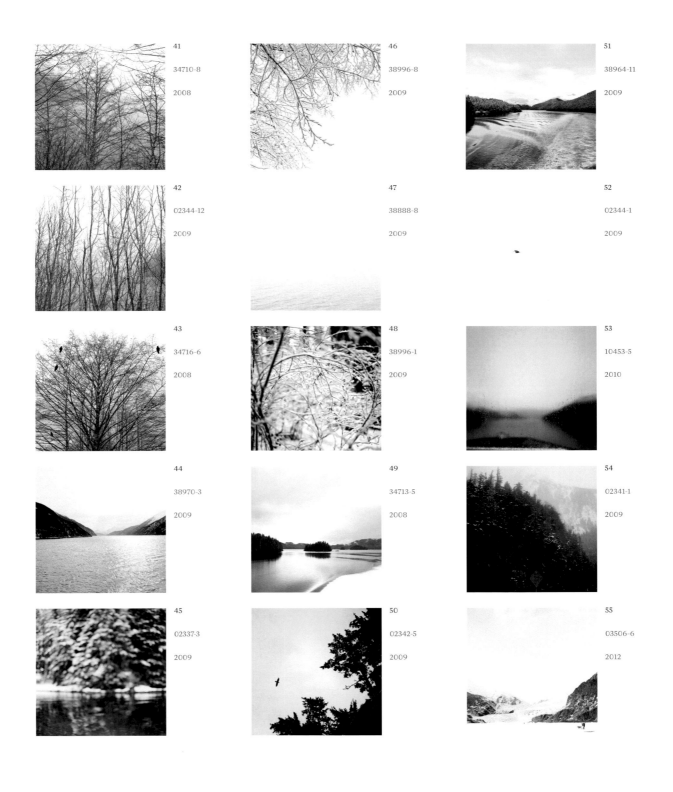

41

34710-8

2008

42

02344-12

2009

43

34716-6

2008

44

38970-3

2009

45

02337-3

2009

46

38996-8

2009

47

38888-8

2009

48

38996-1

2009

49

34713-5

2008

50

02342-5

2009

51

38964-11

2009

52

02344-1

2009

53

10453-5

2010

54

02341-1

2009

55

03506-6

2012

Debra Bloomfield has worked in the landscape for 35 years. Her large-scale color photographs focus on the relationship between interiority and the external world, and question how we use and misuse our land. In 2007, Bloomfield began incorporating field recordings into her working methodology. Turning to an unknown terrain, she immersed herself in the landscape, purposely repeating her movement through the seasons with a contemplative stance.

Her previous work includes *Frida/Trotsky* (1987–1990), a portrait of Frida Kahlo and Leon Trotsky made in their homes in Coyoacán, Mexico, and *Four Corners* (2004), in which photographs from the unforgiving landscape of Colorado, Utah, Arizona, and New Mexico are paired with intimate views of the iconography of Catholic missions. Her *Oceanscape* series, published in *Still* (2008), explores the endless horizon of the sea and is about reflection, patience, and discovery.

Bloomfield's work is represented in numerous museum collections, including the Phoenix Art Museum; the San Francisco Museum of Modern Art; the Museum of Fine Arts, Boston; the Honolulu Museum of Art; the New Mexico Museum of Art, Santa Fe; the Center for Creative Photography, Tucson; University of California, Berkeley Art Museum and Pacific Film Archive; and the Victoria and Albert Museum, London.

An educator in the San Francisco Bay Area since 1977, Bloomfield is currently teaching at the San Francisco Art Institute. In 1992, Bloomfield was the recipient of the San Francisco Foundation's James D. Phelan Art Award for her *Trotsky* series, and in 2005 *Four Corners* received the Western Heritage Literary Award in Photography. She is a founding board member of Photo Alliance in San Francisco, and lives in Berkeley, California.

Lauren E. Oakes is an ecologist, land change scientist, and documentarian. As a National Science Foundation Graduate Research Fellow, she is currently completing her doctorate degree at Stanford University in the Emmett Interdisciplinary Program in Environment and Resources. She studies the social and ecological responses to yellow-cedar decline, a forest dieback associated with climate change in British Columbia and Southeast Alaska. Lauren is the 2011 recipient of the Wilderness Society's Gloria Barron Scholarship and the George W. Wright Climate Change Fellowship for her research on remote Wilderness lands and protected areas. She has written and photographed for the *New York Times* Green blog.

Dr. Rebecca A. Senf is Norton Family Curator of Photography, a joint appointment at the Center for Creative Photography and the Phoenix Art Museum. Senf grew up in Tucson and studied the History of Photography as an undergraduate at the University of Arizona. She earned a PhD in Art History at Boston University and while in Boston worked on the Museum of Fine Arts, Boston's major exhibition *Ansel Adams from the Lane Collection*, for which she coauthored the related catalogue. Her book, *Reconstructing the View: The Grand Canyon Photographs of Mark Klett and Byron Wolfe*, was released in 2012.

Terry Tempest Williams is "a citizen writer," a writer who speaks on behalf of an ethical stance toward life. A naturalist and fierce advocate for freedom of speech, she consistently works to demonstrate that environmental issues are ultimately matters of social justice.

Her writing has appeared in the *New Yorker*, the *New York Times*, *Orion Magazine*, and multiple anthologies worldwide as a crucial voice for ecological consciousness and social change. She is the author of numerous books, including the environmental literature classic *Refuge: An Unnatural History of Family and Place*, as well as *Pieces of White Shell: A Journey to Navajoland*; *An Unspoken Hunger: Stories from the Field*; *Desert Quartet: An Erotic Landscape*; *Leap*; *Red: Passion and Patience in the Desert*; *The Open Space of Democracy*; *Mosaic: Finding Beauty in a Broken World*; and *When Women Were Birds: Fifty-Four Variations on Voice*, published in 2012.

In 2006, Williams received the Robert Marshall Award from the Wilderness Society, their highest honor given to an American citizen. She also received the Distinguished Achievement Award from the Western Literature Association and the Wallace Stegner Award from the Center for the American West. She is the recipient of a Lannan Literary Fellowship and a John Simon Guggenheim Fellowship in literary nonfiction.

Williams is currently the Annie Clark Tanner Fellow in Environmental Humanities at the University of Utah and was recently a Montgomery Fellow at Dartmouth College. She divides her time between Castle Valley, Utah, and Moose, Wyoming, where her husband, Brooke Williams, is the Field Advocate for the Southern Utah Wilderness Alliance.

Wilderness *came about as Terry Tempest Williams and I sat one day on a bench sipping coffee and she said, "We should* another book together." When I sit and listen to Terry, I am always amazed at what she knows about the land and how mu is unfamiliar to me. This is where I began to understand wilderness and those individuals who have worked to protect it: A Leopold, Richard Nelson, Wallace Stegner, and Mardy Murie, to mention a few.

This body of work would not have been possible without Terry telling me, "There is a particular place in the woods up no you need to see." As I first entered the woods, the moist air and soft spongy floor caught my attention; as I was standing sti suddenly heard an unfamiliar sound break the silence from above. The common raven, Corvus corax, drew me into this n terrain and captured my soul's full attention for five years.

I am beholden to Rebecca A. Senf, at the Phoenix Art Museum, for her support and understanding of the project. Her wor in this book illuminate and elegantly tell my creative story. I also wish to thank Deborah Klochko and Katherine Ware for th support of my Wilderness work.

This book has closed a circle with the help and dedication of Lauren E. Oakes. Once a studio assistant, now a scholar a biologist, Lauren has written a historical text on wilderness for this publication.

I would like to thank Peter Landres, ecologist of the Aldo Leopold Wilderness Research Institute, and Cindy Shogan, exe tive director of the Alaska Wilderness League, for their professional guidance with regards to wilderness; Andrew Thoms of Sit Conservation Society; Kent Hall and Beverly Minn, who helped guide me into the landscape; and Cheryl and Thomas Jord who always welcomed me into their warm home.

I am grateful to UNM Press and especially John W. Byram for being able to look deeply into my Wilderness photographs a recognize the importance of bringing this work to fruition as a book. My appreciation goes to Maya Allen-Gallegos, producti manager at UNM Press, for keeping all the pieces together during the production of Wilderness.

I can't thank Bob Aufuldish enough for his creative wisdom and brilliance with the design of this book.

I am grateful to the galleries that have supported my work and made it possible for me to continue down my creati path: Etherton Gallery and Dawne Osborne, Fahey/Klein Gallery and Gisele Schmidt, Robert Koch Gallery and Ada Takaha Richard Levy Gallery and Viviette Hunt, and Julie Nester Gallery and Doug Nester. A special thank you to Patti Gilford a Thomas V. Meyer.

Chris Barnett, Bob Cornelis, Reinhold Gras, Daegon Keller, Steve Kim, Wing Law, Chris McElrath, Michael Pazdon, Pc Porcher, Brenda Sharp, Michael Thompson, and Evan Walsh whose technical expertise and support of my art exceeds all standar

I'd like to thank my graduate students who helped me along the way with their technical support: Seza Bali, Scott Pola Marie-Luise Klotz, and Stefanie Loveday, whose devoted assistance for two years I will always be indebted for.

My family in its most wonderful complexities: Jessica Bloomfield Buffington, my daughter and muse, Jake Bloomfi Misrach, my son, the musician and composer who endlessly sat by my side to aid me in creating my soundscapes. Richard a Myriam Misrach for their exquisite insights and support. My wonderful brother, Tony. My sisters, Bonnie and Barbara, w always liked to take a walk in the woods. And to my mother who is always up for an adventure.

And to my husband and best friend, George Buffington, who traveled once again on this seven-year Wilderness journey with

—Debra Bloomfield, 2013

To *Mom*

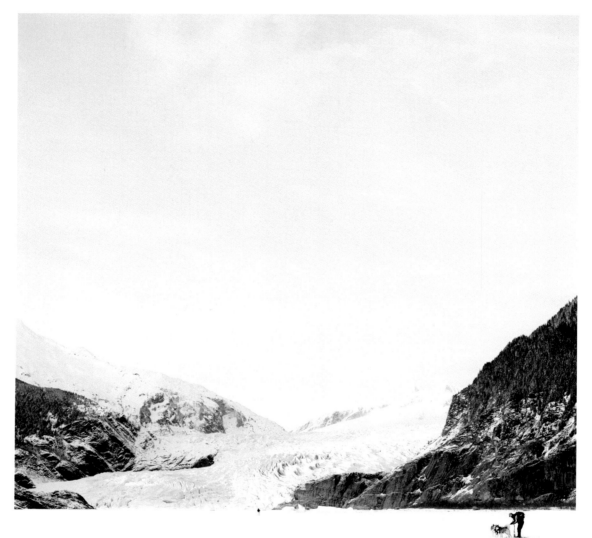

Bureau of Land Management
www.blm.gov/wo/st/en/prog/blm_special_
areas/NLCS/Wilderness.html

U.S. Fish and Wildlife Service
www.fws.gov/refuges/whm/wilderness.html

U.S. Forest Service
www.fs.fed.us/recreation/programs/cda/
wilderness.shtml

National Park Service
wilderness.nps.gov

. . .

Aldo Leopold Wilderness Research Institute
790 East Beckwith Ave.
Missoula, MT 59801
www.leopold.wilderness.net

Arthur Carhart National Wilderness Training Center
James E. Todd Building
32 Campus Dr.
Missoula, MT 59812
carhart.wilderness.net

National Forest Foundation
Building 27, Ste. 3
Fort Missoula Rd.
Missoula, MT 59804
www.nationalforests.org

The National Wilderness Stewardship Alliance
PO Box 5293
Reno, NV 89513
www.wildernessalliance.org

The Wilderness Institute
College of Forestry and Conservation
The University of Montana
32 Campus Dr.
Missoula, MT 59812
www.cfc.umt.edu/Wi

The Wilderness Society
1615 M St. NW
Washington, DC 20036
www.wilderness.org

Society for Wilderness Stewardship
PO Box 2667
Bellingham, WA 98277
wildernessstewardship.org

. . .

Alaska Conservation Foundation
911 W 8th Ave., Ste. 300
Anchorage, AK 99501
alaskaconservation.org

Alaska Wilderness League
122 C St. NW, Ste. 240
Washington, DC 20001
www.alaskawild.org

Sitka Conservation Society
PO Box 6533
Sitka, AK 99835
sitkawild.org

The Murie Center
1 Murie Ranch Rd.
Moose, WY 83012
www.muriecenter.org

Greater Yellowstone Coalition
215 S. Wallace Ave.
Bozeman, MT 59715
www.greateryellowstone.org

Jackson Hole Conservation Alliance
685 S. Cache St.
Jackson, WY 83001
www.jhalliance.org

New Mexico Wilderness Alliance
142 Truman St. NE
Albuquerque, NM 87108
www.nmwild.org

Selway-Bitterroot Frank Church Foundation
PO Box 8103
Missoula, MT 59807
www.selwaybitterroot.org

Southern Appalachian Wilderness Stewards
243 Ironsburg Rd.
Tellico Plains, TN 37385
www.trailcrews.org

Southern Utah Wilderness Alliance
425 East 100 South
Salt Lake City, UT 84111
www.suwa.org

Quote on page 4: Craighead, Charles, and Bonnie Kreps. *Arctic Dance: The Mardy Murie Story*. Portland, OR: Graphic Arts Publishing, 2002.
Photo on page 24: "OJM loads up Mardy's bag," 1961, by Charlotte E. Mauk. Courtesy of Charlotte E. Mauk slides, Archives and Special Collections, Consortium Library, University of Alaska Anchorage. Every effort has been made to identify and contact the copyright holder of "OJM loads up Mardy's bag."
Quote on page 26: Austin, Michael, ed. *A Voice in the Wilderness: Conversations with Terry Tempest William*s. Logan: Utah State University Press, 2006.
Quote on page 107: The Wilderness Act, Public Law 88-577, 16 U.S.C. §§1131-1136 (1964), Section 2(a).

Library of Congress Cataloging-in-Publication Data

Wilderness / Debra Bloomfield ; essays by Lauren E. Oakes, Rebecca A. Senf, and Terry Tempest Williams.
 pages cm
ISBN 978-0-8263-5429-7 (cloth : alk. paper) —
ISBN 978-0-8263-5431-0 (electronic)
 1. Landscape photography—United States. 2. Wilderness areas—United States—Pictorial works. 3. National parks and reserves—United States—Pictorial works. 4. Bloomfield, Debra, 1952– I. Oakes, Lauren. II. Senf, Rebecca A. III. Williams, Terry Tempest. IV. Bloomfield, Debra, 1952– Photographs Selections.
 TR660.W496 2013
 779'.36—dc23
 2013018655

Editor: John W. Byram
Designer: Bob Aufuldish, Aufuldish & Warinner
Sound Producer: Jake Bloomfield-Misrach
Production Manager: Stefanie Loveday
Cartographer: Jake Coolidge